GEOFFREY HOLDER

THE PAINTER

GEOFFREY HOLDER: THE PAINTER

March 25 through May 21, 1995

Organized by the

University Art Museum

University at Albany

State University of New York

The exhibition catalog is funded in part by a grant from

Philip Morris Companies Inc.

Contents

To Dea
Cassandra
with
Best wishes
yours
[signature]
2004.

Graphic Design and Production: University Art Museum

Designed and typeset by Zheng Hu

2,000 copies were printed by

Brodock Press, Inc., Utica, New York.

Library of Congress Catalog Card Number 95-060481

ISBN 0-910763-13-5

Foreword

This catalog and the accompanying exhibition celebrate the extraordinary talents of Geoffrey Holder. In paintings and drawings that reverberate with emotional, physical, and intellectual presence, Holder gives concrete form to the creative energy and passion that have fueled his art during a long and distinguished career. Since he first gained recognition as a visual artist while still a teenager in his native Trinidad, Holder has received numerous awards, including a Guggenheim Foundation Fellowship, and his work has been acquired by public and private collections.

Holder's paintings serve as a "gateway" to understanding what he is about as an artist; as such they reveal more of him than the other art forms that have engaged him. His sense of community, love of bright, clear color, richly patterned fabric, and understanding and knowledge of the human form—its structure, rhythms and complicated rituals—are all revealed within a willed imposition of order. His ability to depict the visual equivalent, or imprint, of memory, dream, or felt experience is also strikingly evident in his paintings.

Marijo Dougherty

Director
University Art Museum

Acknowledgments

The organization of the exhibition and the production of the catalog would not have been possible without the enthusiastic involvement of the artist. I am, therefore, deeply indebted to Geoffrey Holder. I would also like to acknowledge the hard work of the museum staff, in particular that of Zheng Hu, who designed the beautiful catalog that accompanies the exhibition. I am also grateful to George Weymouth of the Brandywine River Museum, and to Joseph Mazo and Helen Lawrenson for their writings on the artist.

Finally, we are most grateful to our two principal sponsors for their timely vote of confidence: Philip Morris Companies Inc. (Stephanie French, vice president of corporate contributions and cultural affairs), for its support of the catalog, and The Armory Automotive Family (Donald Metzner, CEO), for its support of the exhibition.

M.D.

Catalog Statement

One doesn't *know* Geoffrey Holder so much as *experience* him. His extraordinary talents are many and varied, but above all, he is a very deep and emotional painter. Geoffrey's paintings capture and reflect his own life experience. He uses his knowledge of the world and his unique perspective to express emotion in his work, be it *Saturday Night Social* or *Going Home*. The sensuous lady at night and the other portraits express universal emotions, and they uplift and immerse us in the emotional complexity of existence. They are painted with the insight of a man who has experienced life fully.

Many years ago, I was invited to visit the loft where the Holder's live—an enormous white space with white walls, white floors and white furniture—a space filled with strong world folk art: heads, torsos, sculptures, a mass of shapes, textures and colors. More vivid color coming from Holder paintings stacked here and there—portraits, nudes and landscapes.

Geoffrey was discussing many things with wonderful animation and enthusiasm—in his unmistakable voice. Slowly, the strange sense of a powerful presence came over me. I looked down the length of the loft and this incredible vision floated toward me. It was Carmen, draped in vivid pinks, reds and yellows. She moved with as much dignity and grace as I have ever seen. She floated right into the world of Geoffrey Holder. The boldness of color, her grace and dignity and sheer confidence embodied his work and expressed his world. I was filled with awe, dumbfounded and shaking—and when I look at Geoffrey's paintings today, I am again.

George "Frolic" Weymouth

Brandywine River Museum
Brandywine Conservancy
Chadds Ford, Pennsylvania

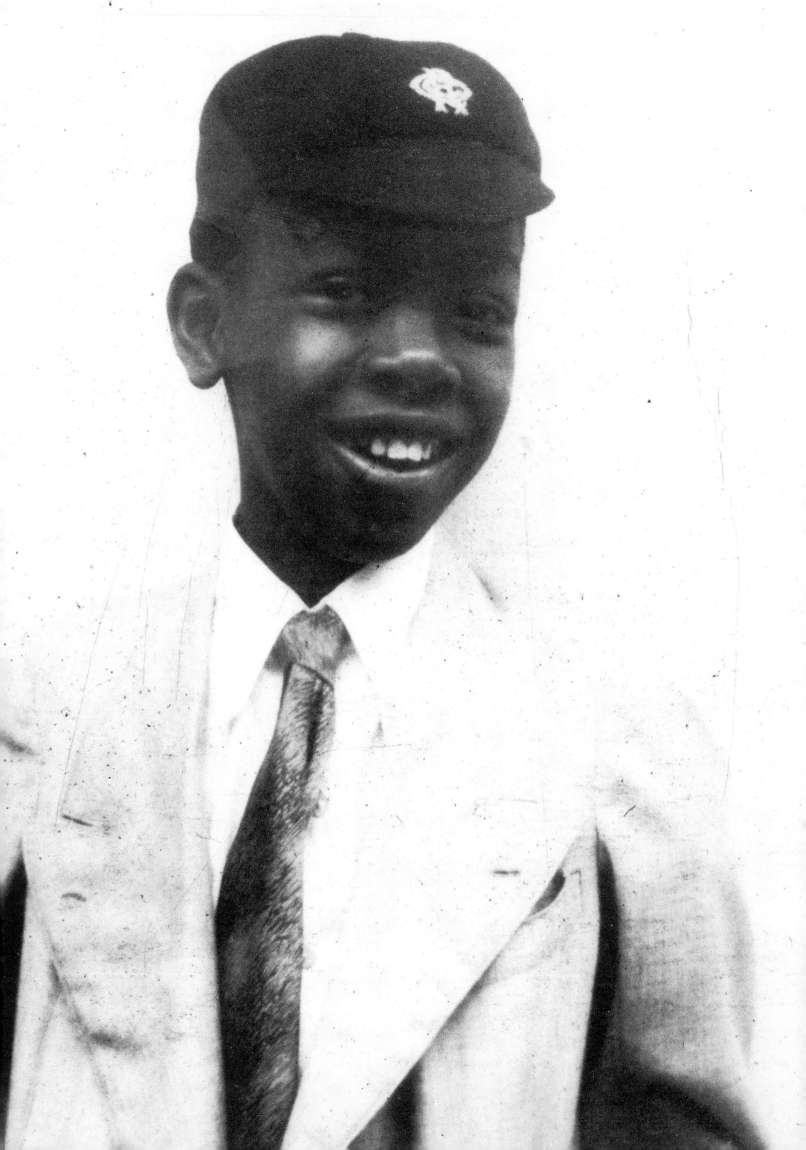

Geoffrey Holder: Reflections on the Artist

Every once in a while there comes along a man so multitalented in the arts that no single field can satisfy his creative energy. Thus we get a Wyndham Lewis in England or a Jean Cocteau in France, men of such lush cultural fertility that they bring to mind the manifold richness of art in the days of the Renaissance.

Geoffrey Holder extends the tradition of these exuberant virtuosi and continues to push the limits of his creative powers. Since arriving in this country from his native Trinidad, he has achieved recognition as a painter, actor, dancer, singer, choreographer, composer, librettist, costume designer, scenic designer, writer, and photographer.

One of his most notable talents, that of painter, is the one least known to the public. He is an artist with a sensuous appreciation of shape and form and the courage to render his carefully chosen colors. In 1956 he was awarded a Guggenheim Foundation Fellowship enabling him to continue working not as a performer but as a painter. Today, his pictures can be found in museums and private collections worldwide.

The artist at age 12 in his Queen's Royal College uniform, Trinidad, 1942.

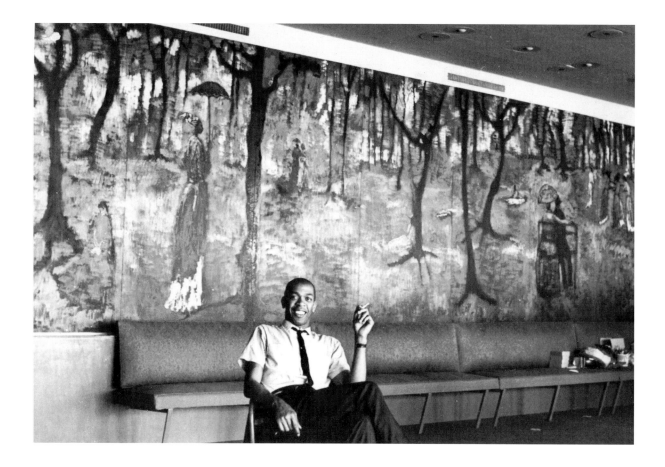

(ABOVE) The artist during installation of a mural commission, 30 feet x 8 feet, Trinidad Hilton, 1960.

(RIGHT) The artist with dancer Scoogie Brown, Trinidad, 1949.

(FAR RIGHT) The artist with Rouben Ter-Arutunian, set and costume designers for John Butler's Chamber Ballet, First Spoleto Festival, Italy, 1958.

(LOWER RIGHT) Costumes designed by the artist and sets designed by Alexander Calder for John Butler's Chamber Ballet, First Spoleto Festival, Italy, 1958.

In a mural Holder painted for the dining room of the Trinidad Hilton Hotel, figures walk among the trees and the sweet, misty greens provide a background for the visual shock of long, red dresses. The focal point of a more recent painting is the faces of a passionately embracing couple; they are nearly devoid of expression. The ecstasy of the meeting is conveyed by color—vibrant yellow and red, and the sharp contrast of the woman's black arm reaching up along her lover's back. For Holder, color is the voice of the universe:

> *Blue sings, red shouts. Grey can smile or it can cry. In New York City*
> *people seem to be frightened of color because they live in a world*

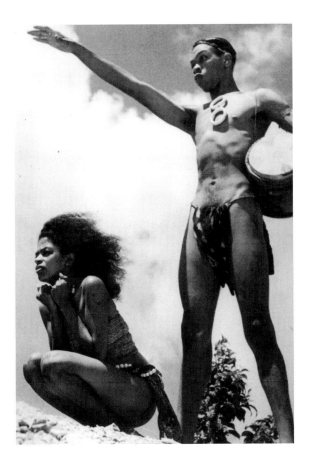

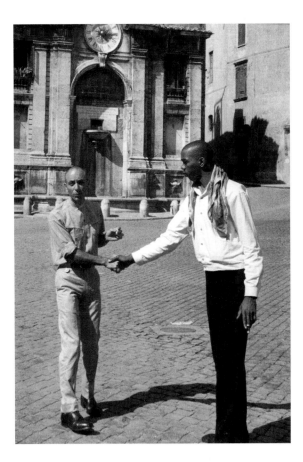

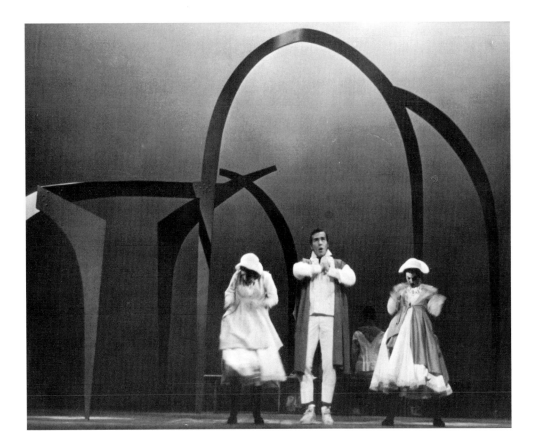

11

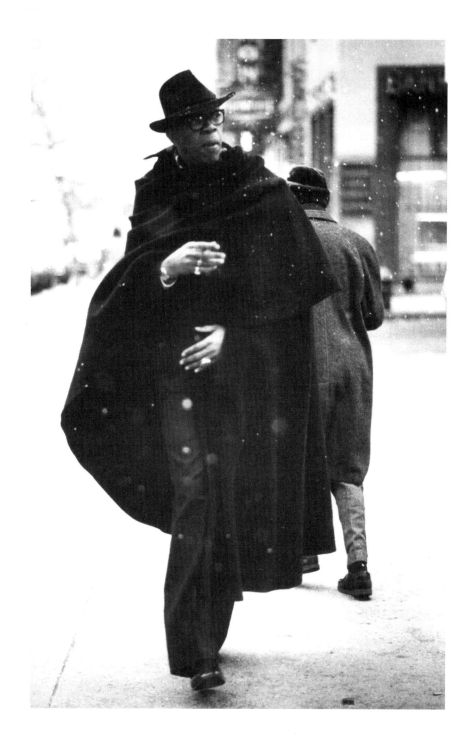

without it. But I was raised in a world filled with color, and nobody

ran and hid from it. When I was in Trinidad, I attended a lecture by a

historian from England who kept talking about Gainsborough blue and

how lovely and sweet and delicate it was. She told us that our blues

were too strong, too violent, too unrealistic. I wanted to shout at her,

"Look up at the sky and see the blue you say is unrealistic!"

You choose your palette early; you work for color when you see

it. Gainsborough chose his blue because of his climate. When you first

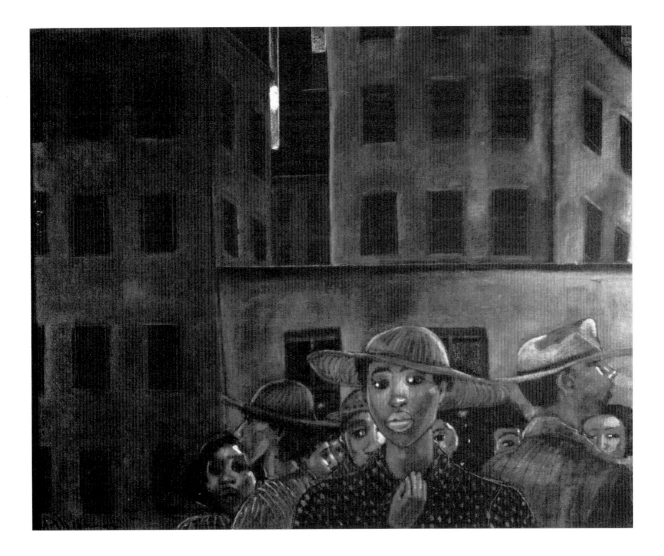

(ABOVE) *After Work III*, 1992, oil, 24 x 30 inches.

(LEFT) The artist on the town, New York, 1969.

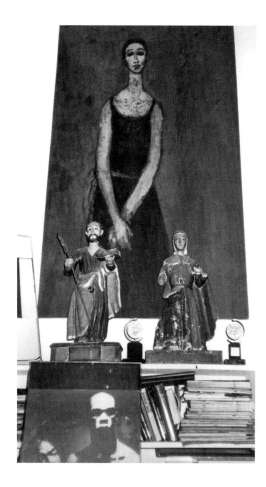

(LEFT) *Portrait of Carmen de Lavallade*, 1973, oil.

(BELOW) The artist with his paintings, New York, 1984.

(RIGHT) The artist at home, New York, 1990.

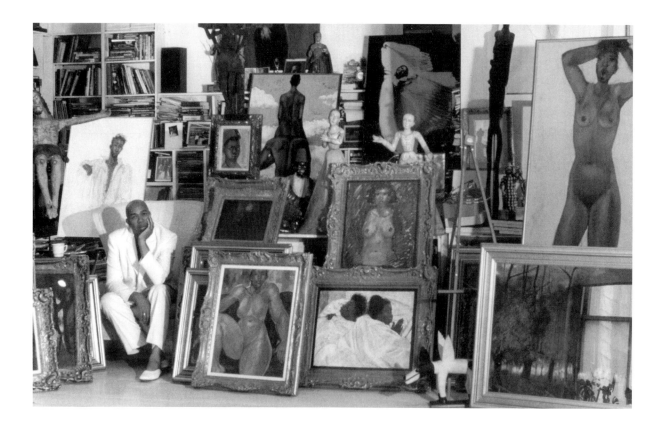

14

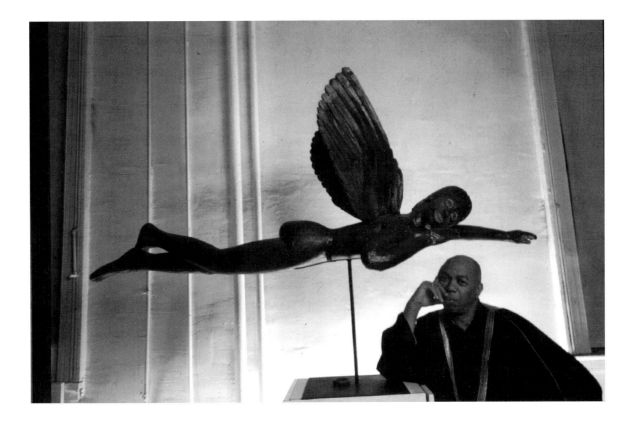

see French Impressionist paintings, you can't believe a sky can really be

that shade, but when you see the color of the light in Paris, you

understand that the artists were painting exactly what they saw.

I hear people call the colors of Haitian paintings 'gaudy.' I

hate that word. It's derogatory, and it only means that people have

never been to a place where the colors really shine and where people

enjoy vibrance and life.

It is the same with everything he does. Beneath his apparent simplicity of manner lies a sure inner knowledge of what he is doing and of exactly the right way in which to do it. One art critic summed it up when he wrote of Holder's paintings, "He seems to capture the magical, beautiful intentions of life...a sense of culture so complete

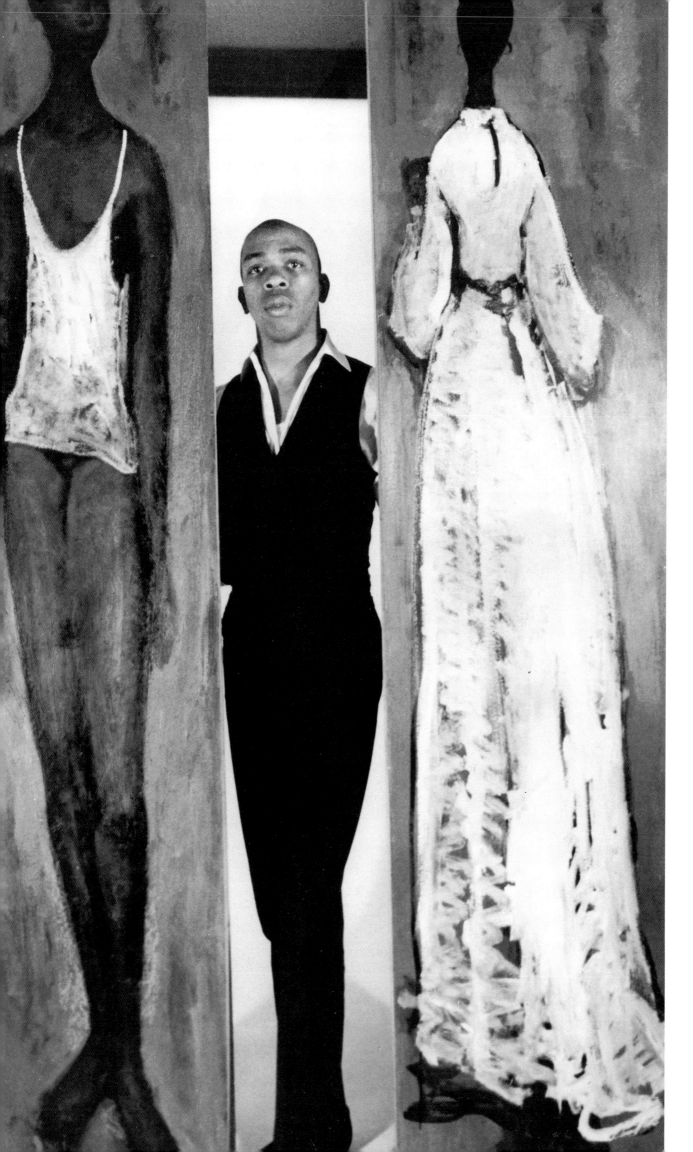

and so balanced that the artist who works within it cannot strike a wrong note." To Holder, art is life, and living is artistic expression. What makes him a true prototype of the Renaissance man is not only his impressive achievements but the culture underlying them and the fact that whatever he does springs from a strong interior need to give substance to this culture. He would be doing these things anyway, unknown or famous, for money or for free.

Holder's artistic gifts, like his ambassador's manners, come from his remarkable family. Of course he dances: his parents met at a dance and, Holder says, "they never stopped dancing together after that." His mother was a talented seamstress and Holder traces his love of fabric to time spent watching her sew, and his love of theatre, as well as of the movies, to the stories she told him.

Being self-taught does not strike him as the least bit odd or unusual. He comes from a country where practically everyone sings or dances or paints or plays a musical instrument as a natural and essential part of life. As he

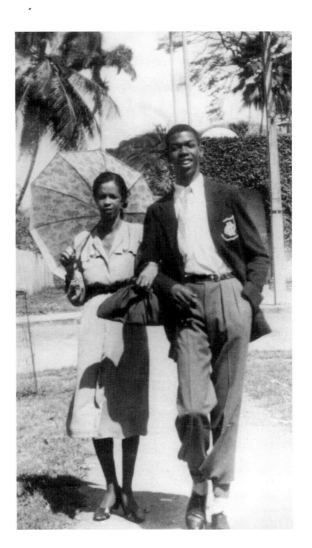

(ABOVE) The artist and his mother after church, Trinidad, 1949.

(LEFT) The artist with his paintings, Paris, 1965.

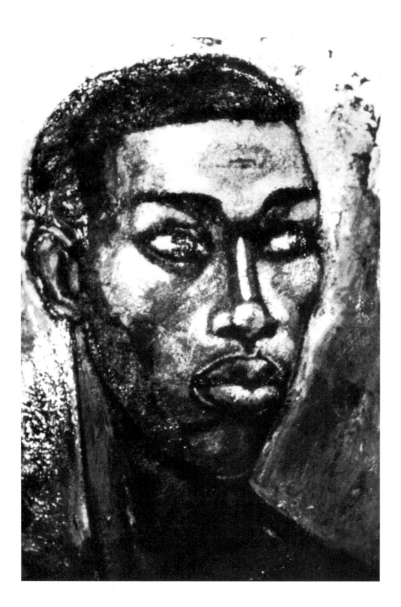

(ABOVE) *Self-Portrait, Age 21*, 1951, oil.

(RIGHT) The artist with his paintings, New York, ca. 1960.

wrote in an article on music for *The New York Times*, "The musician may not be able to read music, but who knows, who cares about reading music when one can blow his soul through a cheap trumpet? The poor Trinidadian who creates a new instrument because he cannot afford to buy one—drums from oil cans, cymbals from tops of garbage cans—is no less a musician than the Juilliard graduate."

He became a painter the way he became a dancer, by growing up with the art. He had no formal training, he says, but "learned by doing, by looking at people, by watching my artist brother Boscoe [an older brother, also a painter], by hearing him talk with other painters." In school he got as far as the fourth form at the Queen's Royal College and then left to work as a clerk on the docks. He began to devote more and more time to painting and dancing, and in this his chief stimulant was the approval of his brother Boscoe. "Some people paint and dance for the critics," he has said, "but I paint and dance for my brother."

When Boscoe left Trinidad for New York, and later, London,

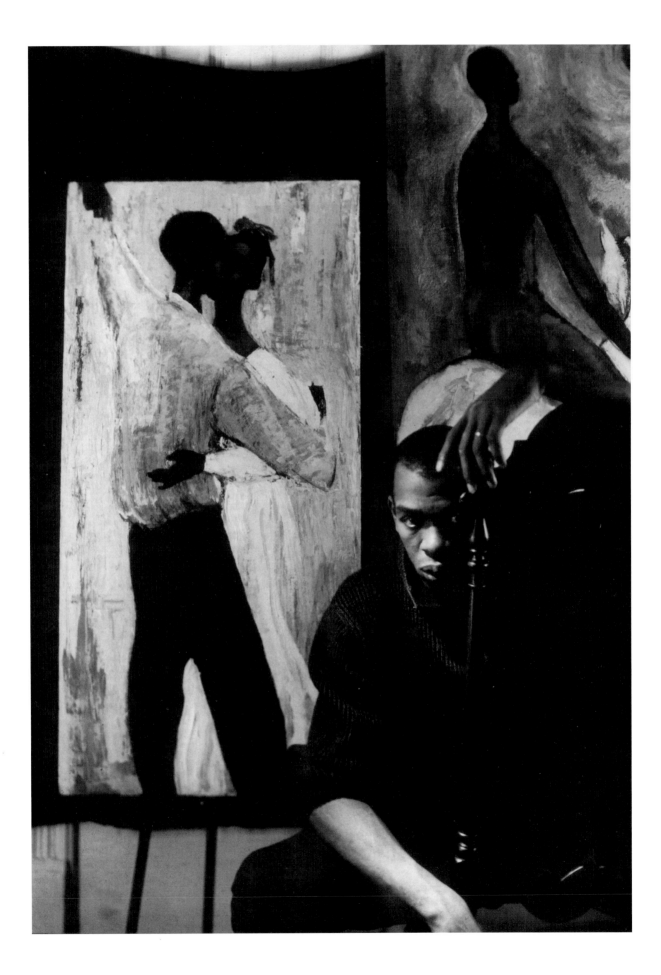

19

Geoffrey took over his brother's dance company. In 1951 and 1952, he produced three revues that resulted in an invitation to represent Trinidad at a Caribbean festival in San Juan, Puerto Rico. He financed the trip to Puerto Rico by selling five of his paintings. He later sold 17 paintings to raise passage money to New York, after Agnes de Mille and Walter White, who had both seen him dance, suggested that in this city is where his future lay.

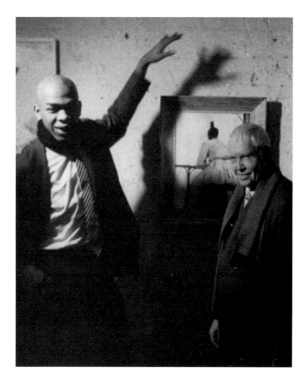

(ABOVE) The artist at his first exhibition with Carl Van Vechten, New York, 1954.

(UPPER RIGHT) The artist with his paintings, New York, 1957.

(LOWER RIGHT) The artist with Adlai Stevenson and painting of Carmen de Lavallade and their son, Leo, New York, 1963.

All this time, he was turning out paintings, working half the night on them, painting on anything that was at hand. While he was in *House of Flowers* on Broadway, a friend took him to Laura Barone, owner of a gallery bearing her name. "I looked at his paintings," she recalled, "and he just sat there without saying a word or moving a muscle. He told me afterward that this was such an important moment that he hardly dared breathe."

His first two shows sold out. He was awarded a Guggenheim Fellowship in Painting for 1956 – 57, and the Corcoran Gallery of Art invited him to exhibition in their show that toured various universities. The art critics wrote of the "tremendous grace and innate dignity" of his paintings, of his "elegant images" and "the gentle lyrical quality" of his work, its "tender stateliness and tranquil strength." One critic called him "a West Indian Manet" adding, "His Trinidadian subjects occupy the warmed

space of his paintings with a quiet monumentality, as if born in them and intending to grow unimpeded, until they reach the sun."

Well-known early collectors like Leonard Colton Hanna, Jr. of Cleveland and William McChesney Martin, then chairman of the board of the Federal Reserve System, were among the first purchasers of his paintings. When Holder later visited Hanna's home, he was pleasantly surprised to see two of his early oils surrounded by Picassos, Renoirs and Modiglianis.

Whether he is working in oils or in drawing pencil, Holder's painting is indeed a study in "sensuality and voluptuousness in color and shape." Like the painters and sculptors of native traditions, whose works he collects, his own pictures are direct emotional statements. There is flesh within his frames—loved, abused, lived-in skin and muscle and subcutaneous fat. In a painting done in 1980, a woman kneels, hunched over the bed, while a dimly seen man disappears through a doorway. The woman's arm and shoulder and the deep,

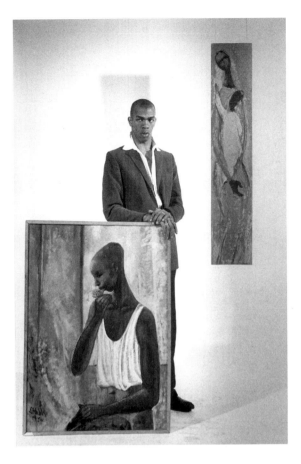

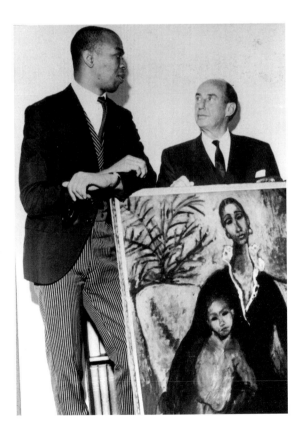

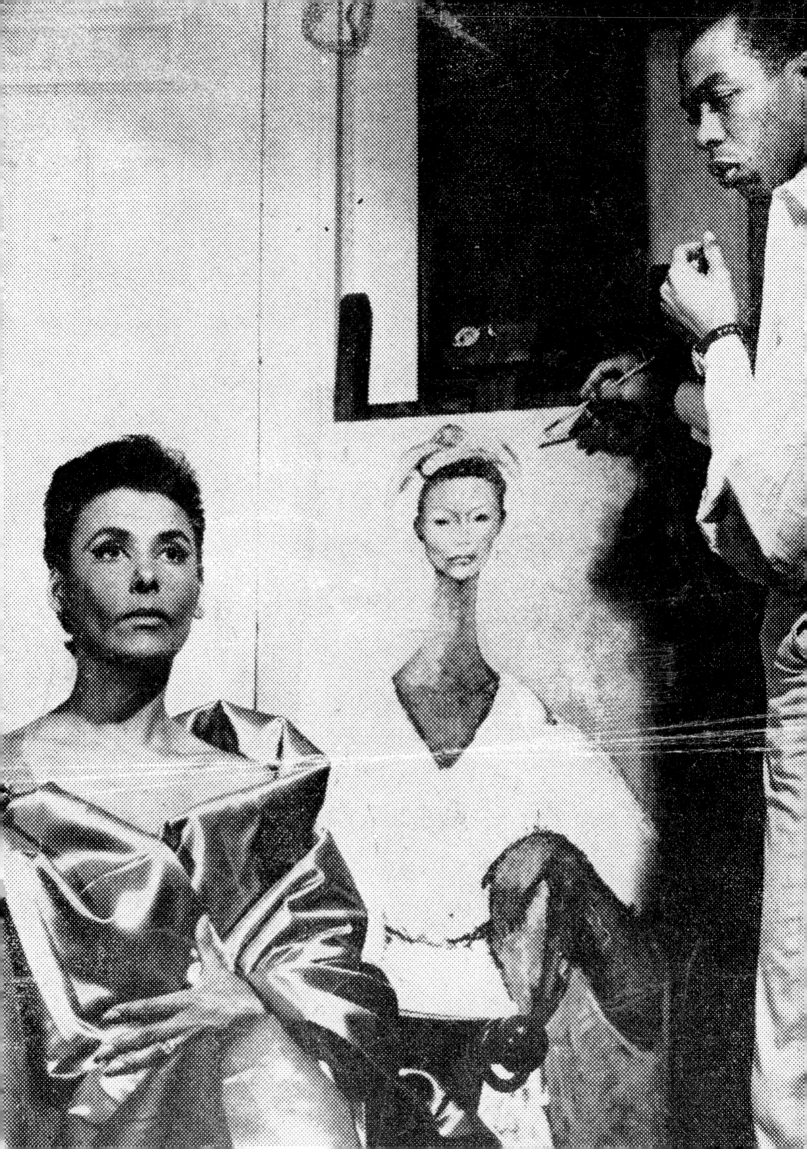

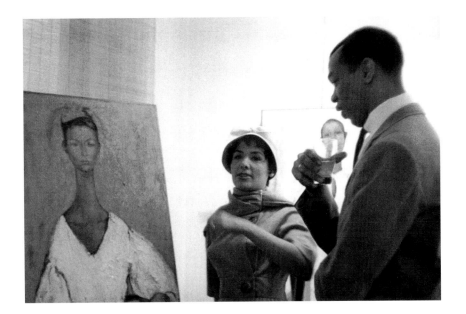

(ABOVE) The artist and Lena Horne at Barone Gallery opening reception, New York, 1959.

(LEFT) The artist painting the portrait of Lena Horne, New York, 1959.

mournful curve of her back glow despondently toward her dangling hair. Her flesh has the weary, flaccid texture of morning; the curve of her buttocks is at once provocative and piteous as the weight of her torso raises it from the sheets.

In another painting, a young girl in a vibrant red party dress looks out, seducing the viewer with huge dark eyes and a teasing mouth. The neckline of her dress is cut low, revealing rich brown skin ("I love the variety of flesh tones," Holder says), and the green background surrounding the subject generates added sexual electricity. The young woman is lovely and desirable—she knows it, Holder knows it, and the viewer knows it.

In Holder's portraits—he has painted such notables as Gian Carlo Menotti, Ricardo Montalban, Anthony Perkins, Lena Horne and Diahann Carroll—it is the

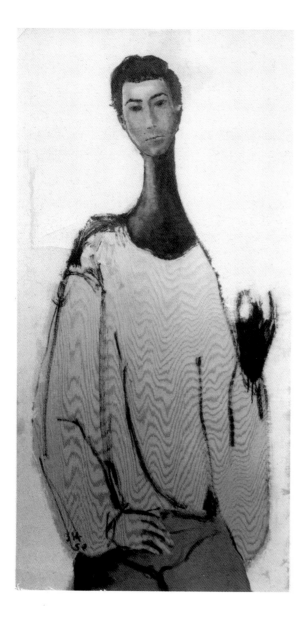

Portrait of Anthony Perkins, oil.

expression of the face and the angle of the head that convey personality. The head may be bent sharply from the softer line of the body, creating tension within the plane of the painting. At times, Holder's subjects seem to be examining the beholder who, in turn, is scrutinizing them.

Holder tends to limit his palette far more in portraits than in his other paintings, although his choice of background color invariably furthers the statement he is making about his subject. However, even in the paintings that entice the eye with lovingly textured fabrics and seductive flesh, Holder maintains a spare style of construction. Nothing extraneous is allowed to dilute the condensed emotion of an observed moment. Each picture focuses upon one intense, dominant image; everything else serves that figure, waiting upon it like a medieval page attending his lord.

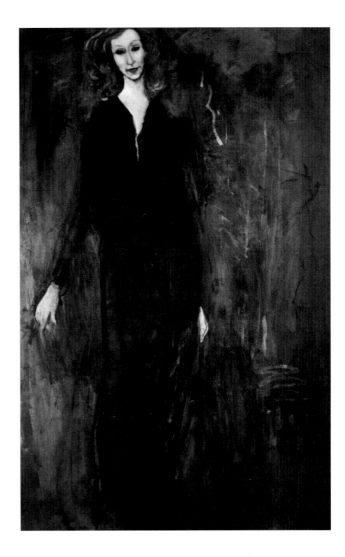

Portrait of Geraldine Page, 1960, oil.

The artist painting the portrait of Geraldine Page,
New York, 1960.

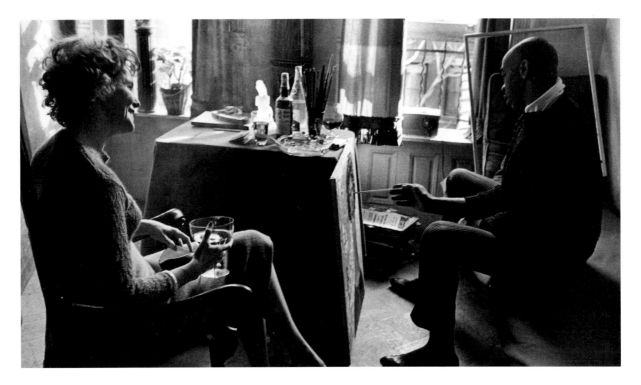

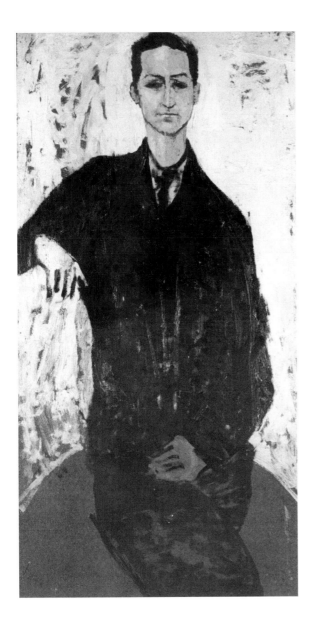 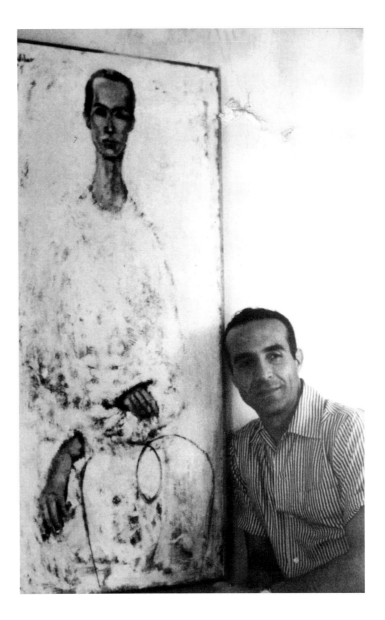

(LEFT) The artist painting the portrait of Susan Kohner
(Mrs. John Weitz), New York, 1974.

(UPPER LEFT) *Portrait of Gian Carlo Menotti*, oil.

(UPPER RIGHT) The actor Ricardo Montalban near his portrait by
the artist, Barone Gallery, New York, 1959.

To Holder there is no conflict among his different careers because everything he does is in harmonious balance with the rest. He says quietly:

I do these things because I have to. They involve my life. I know a quality I want, in painting or in dancing or in anything else, and I do it. They are all a part of each other and of the same thing. When you feel this way, you don't think about money or what comes next. You paint or you couldn't sleep. Then you wake up tomorrow and continue from there. It is a very personal thing. What I have to say is very personal. One doesn't have to do a thing unless one feels it; and one grows by purging this whole thing out. I know exactly what I want to say and I know how to say it. Perhaps that's why some people may think I do things too easily. It would take me a longer time to say what someone else wants to say. But I am saying only what I want to say and in the way I want to say it.

The artist with his painting, *Woman in the Yellow Dress*, 1984, oil.

The above are excerpts from the writings of Joseph H. Mazo and Helen Lawrenson.

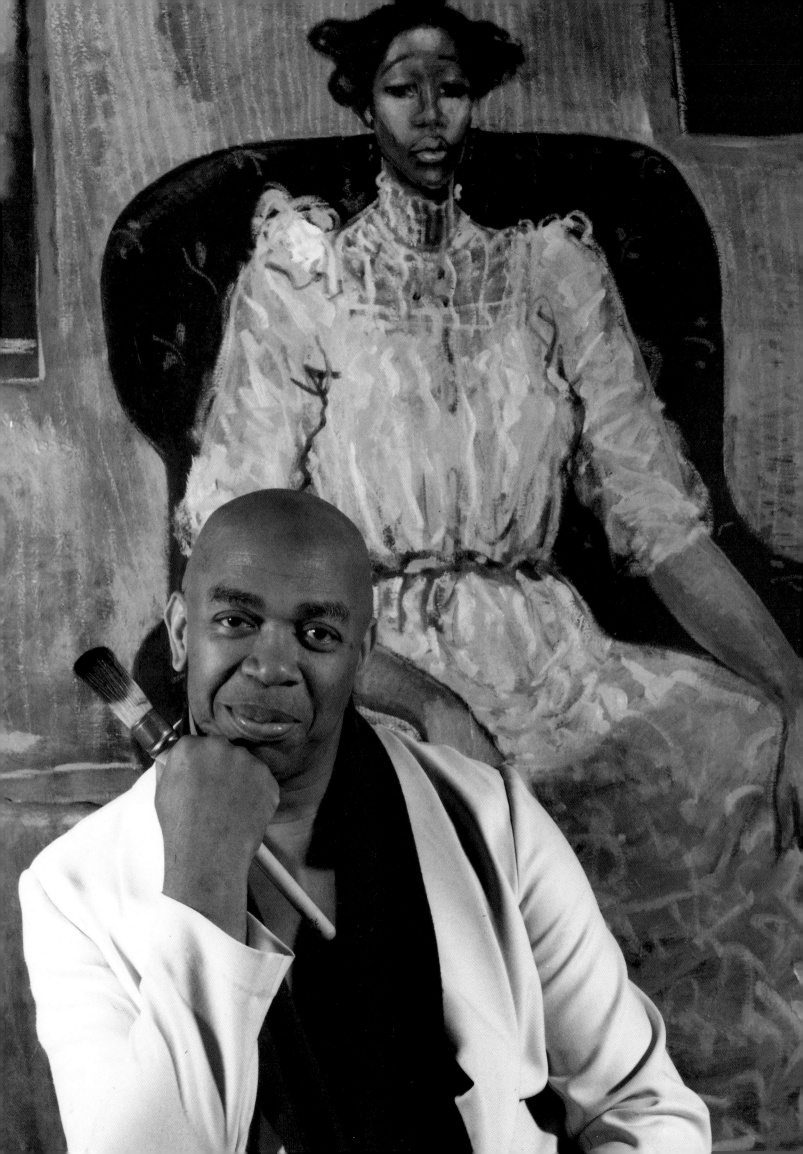

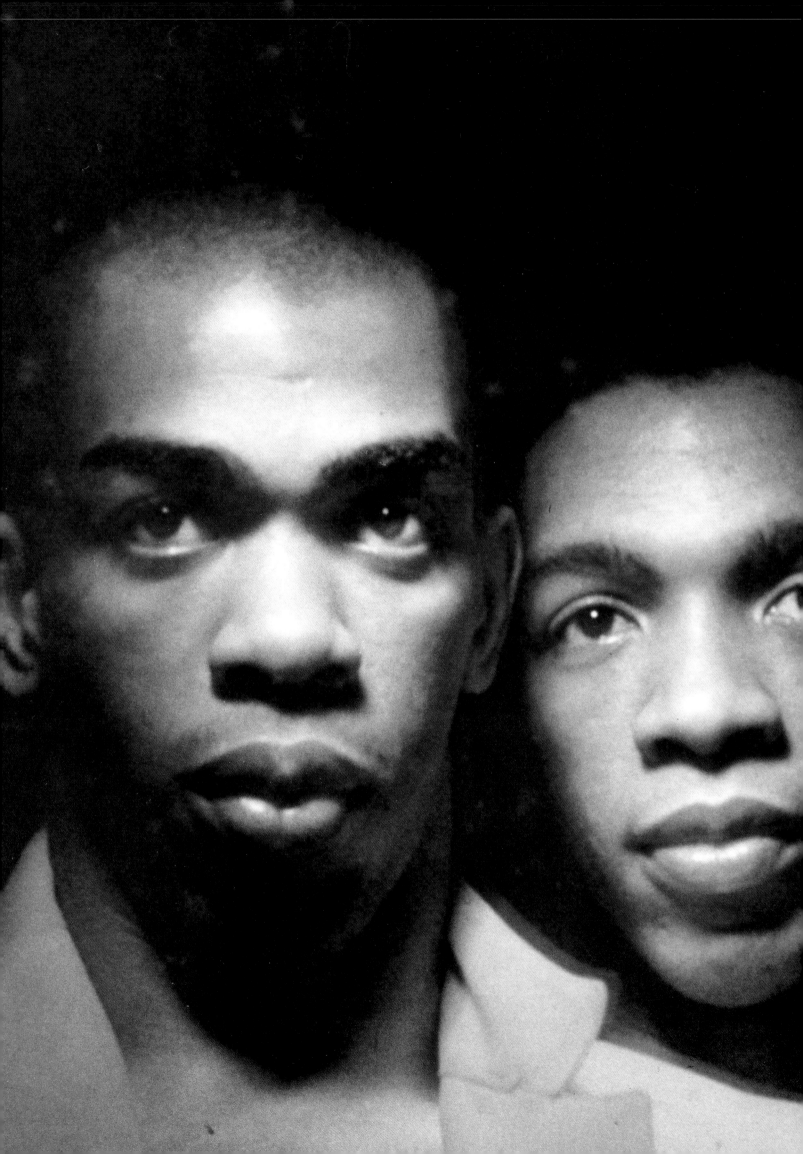

Statement
by the Artist

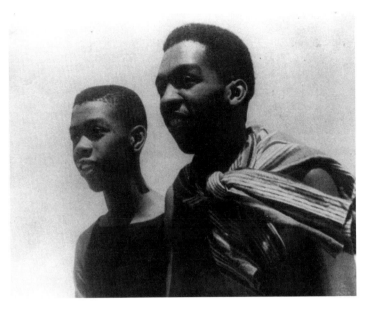

After my grand theft of my brother Boscoe's Windsor-Newton oil paints and the rapid succession of events that followed—my own first oil paintings, the exhibition at the Trinidad Public Library where three of my paintings were sold to Cecil Marquez, M.D. of Harlem Hospital, who chanced upon the exhibition while vacationing in Trinidad—my 15 year old head got quite large! I vowed to have an art exhibition every year, particularly after the local newspaper, *The Trinidad Guardian,* called me a "Boy Wonder" and "An example for the aspiring young artists of Trinidad."

My big ambition had been to exhibition with the Trinidad Arts Society, but after two or three years exhibiting with them, I became disenchanted with the internal politics

(LEFT) The artist and his brother, Boscoe, New York, 1957.

(UPPER) The artist and his brother, Boscoe, Trinidad, 1940.

(LOWER) The artist's first studio, inherited from his brother Boscoe, Port-of-Spain, Trinidad, 1949.

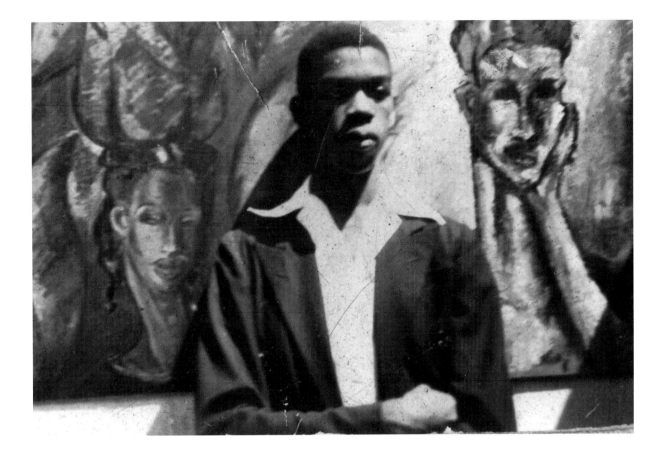

(ABOVE) Proud little Geoffrey with two of his first paintings, Trinidad, 1945.

(LEFT) The artist and his brother, Boscoe, Trinidad, 1940.

and decided to go my own way. During that period, Boscoe held many one-man exhibitions, and once or twice shared an exhibition with a fellow artist. One of them was Warren Brandt, an American soldier stationed in Trinidad during World War II. It was fascinating to see Trinidad through Brandt's eyes.

Apart from his painting, Boscoe had his own dance company and his own radio program where he was known as the "Wizard of the Ivories." He not only excelled as a painter and dancer, but as a pianist as well. With all that music, dance, and art, our home on Richmond Street was the eye of an artistic storm. And like Pygmalion, Boscoe shaped a lot of artists' lives, including mine. He collected art books and left them around, which

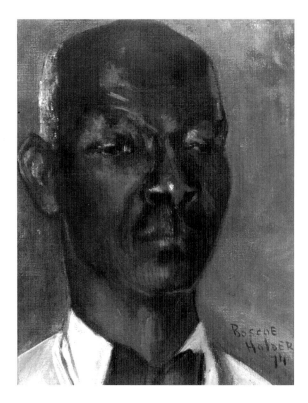

The artist's brother Boscoe's portrait of their father,
Arthur Holder, 1974, oil.

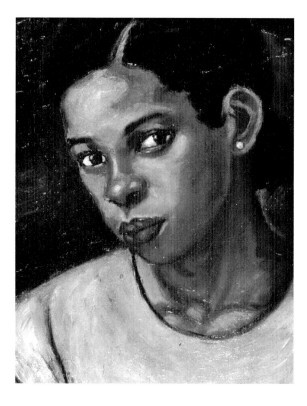

The artist's brother Boscoe's portrait of their mother, Louise
Holder, 1940, oil.

exposed me to so many different worlds. Books that influenced me gave me the freedom to fantasize about unfamiliar cultures: books on Frida Kahlo and Diego Rivera and Miguel Covarrubias, for example. I remember opening up a *Life* magazine spread on Carmen Jones in 1943 with illustrations by Covarrubias. Thirty-two years later, when I designed costumes for *The Wiz*, his illustrations remained in my head because every scene was painted in a different color, and I used that. The tornado costumes in *The Wiz*, which were made of black silk streaming from the head of the dancing girl, were inspired by a John Curry painting of a tornado I recalled seeing in *The Saturday Evening Post*. I was awestruck by a strange woman wrapping herself up in a jersey tube creating all sorts of sculptured forms—Martha Graham in the photo book, *Martha*

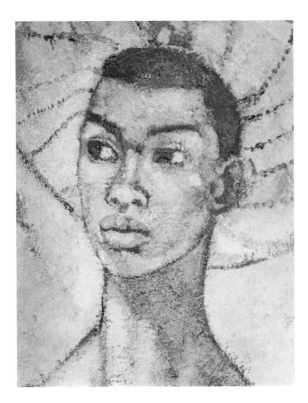

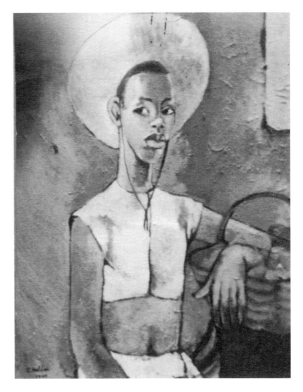

Self-Portrait by the artist at age 18, 1948, oil.

The artist's painting, *Self-Portrait,* hanging in the Barbados Museum, 1947.

Graham Photographed by Barbara Morgan. They all revealed strange, beautiful, exciting, and mysterious worlds—and all had a great influence on me.

Other than Boscoe who painted black people, I was not aware of other painters who painted the golden-hued until I encountered Diego Rivera. The people of Trinidad are so racially mixed and produce the most beautiful offspring: African and Chinese, African and French, African and Indian, African and Portuguese, African and Spanish— you name it, we have it! My grandmother was Martiniquean and my grandfather, French. You could call my mother a Creole. The French enchantment with Africa has always been a wonderful melange for me. I do not know my father's mixture, but I know he was black and strong.

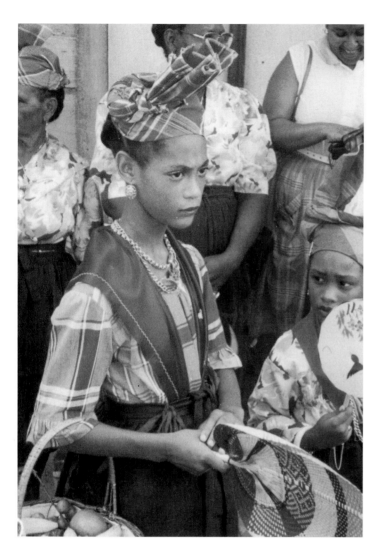

(ABOVE) Young girl, Martinique, 1990.

(RIGHT) The artist's *Portrait of a Martiniquean Woman*, 1948, oil.

As a child I remember the elegant Martiniquean women vendors in the markets in their madras headdresses, foulards, and douettes which are long Victorian dresses draped and tucked in at the waist to show off the lace and embroidered petticoats. On Sundays they would wear all of their heavy gold jewelry to the Catholic church. It was a sight to behold seeing them walk through Woodford Square and the botanical gardens beneath the enormous trees. And heaven help your eyes if those trees were in bloom! Sunday in the park with the Martiniqueans was like Renoir, Seurat and all the French Impressionists' paintings coming to life. Those ladies in their lace petticoats really did me in! Paul Gauguin probably went mad after leaving pastel Paris and wandering through the vividly colored streets of Martinique and the other Caribbean islands. These images have been the strongest influence on my art, much more so than our annual carnival where every young boy and girl is a costume designer. After all, in the Holder household, there were always costumes.

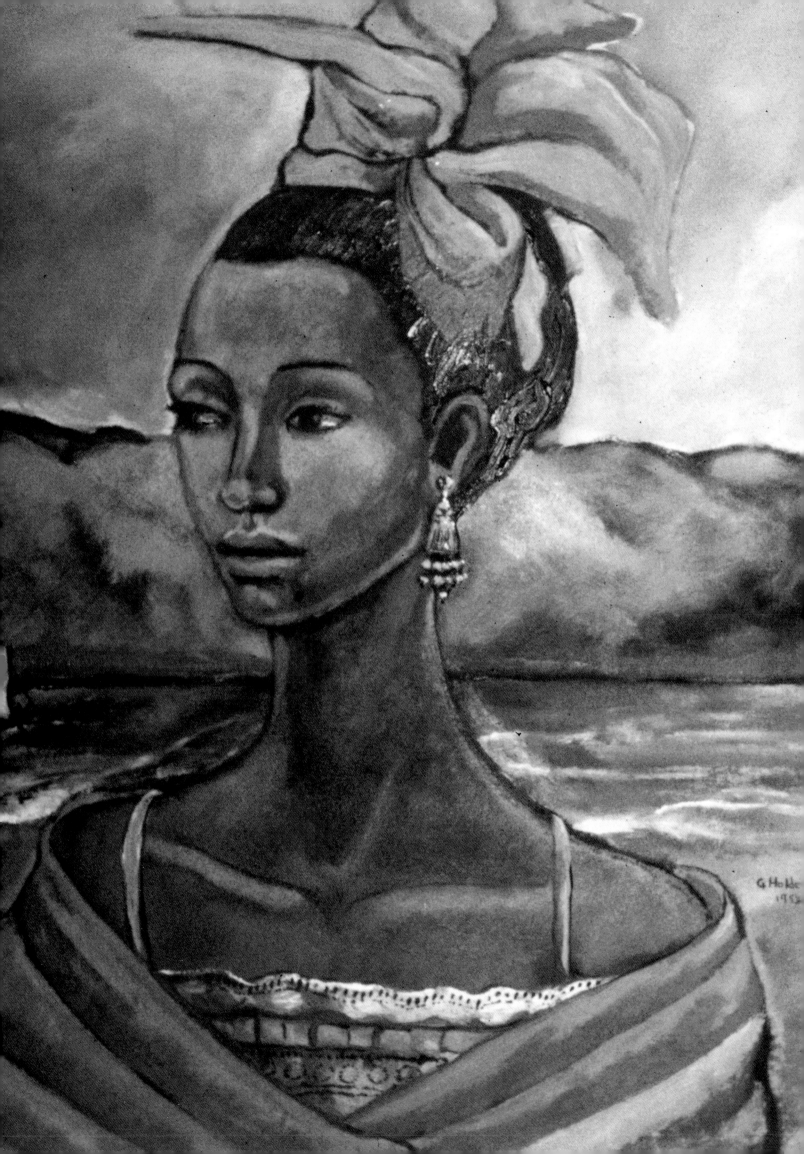

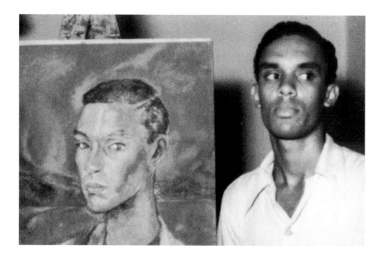

I went to the Queen's Royal College, a very strict, very proper Victorian high school which sat facing a savanna. It was a multiracial school and my friends were Luc, Lee, Lau Sing, Rankhesoon, McCallum and V.S. Naipaul. What a mixture! But my best friend was and still is Carlton Clarke who shared his classical record library with me. We would get high on Rachmaninoff, Dvorak and Debussy. I would scoot home immediately after school to paint. Every afternoon Carlton Clarke or my other friend, (Dr.) Tommy Carr, would hang out listening to good music while I painted. Sometimes we would run away from school in the afternoon and go swimming in the river or down by the

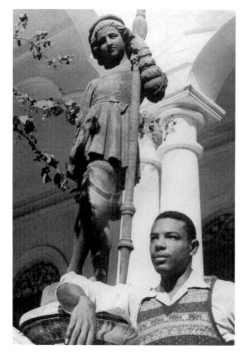

(TOP) Queen's Royal College, Trinidad, where the artist attended school.

(MIDDLE) A friend of the artist, Tommy Carr, with his portrait, Trinidad, 1952.

(BOTTOM) The artist's childhood friend, George Carlton Christopher Hilton Clarke, Trinidad, 1950.

(RIGHT) The artist at age 17 with model in studio, Trinidad, 1946.

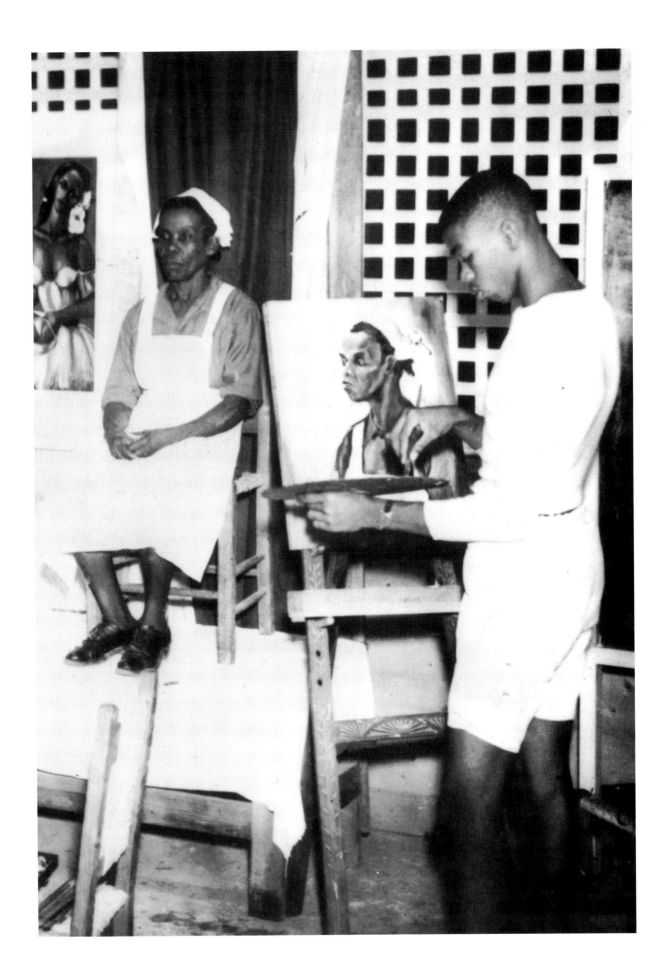

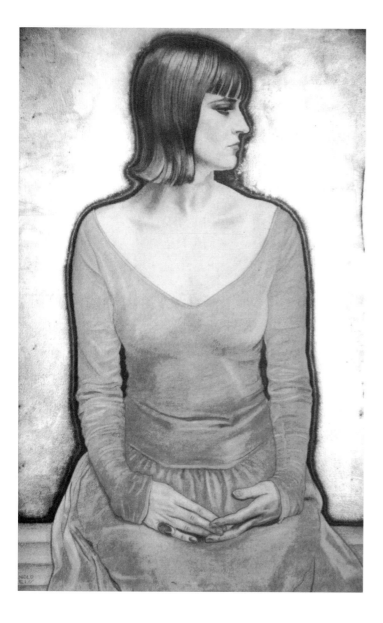

Portrait of Marion Greenwood by the artist Winold Reiss,
ca. 1925, pastel and silverleaf.
Photo courtesy of James Cox Gallery, Woodstock, New York.

sea, or meet our girlfriends and take a walk in the botanical gardens beneath the giant saman trees, looking at all the flowers and orchids in bloom, and occasionally throwing stones into the mango trees to loosen fruit for refreshment.

When Boscoe left for England in the 1950s, with his wife Sheila and son Christian, I inherited the dance company because, as with painting, everything Boscoe did I wanted to do. I also acquired a government job as a clerical assistant on the waterfront which enabled me to buy more canvasses for painting, more fabric for costumes and provided money with which to produce shows at the Royal Victoria Institute.

During those years, many people came to Trinidad in search of Boscoe. In his absence they discovered me: people like Leonard Hanna, the Cleveland art collector; Horace Sutton, editor of *The Saturday Review of Literature*; the head of the Artists' Equity, Stuyvesant Van Veen, and his wife, Fran; and, painter Marion Greenwood. The shows became so successful that a friend, Donald Bain,

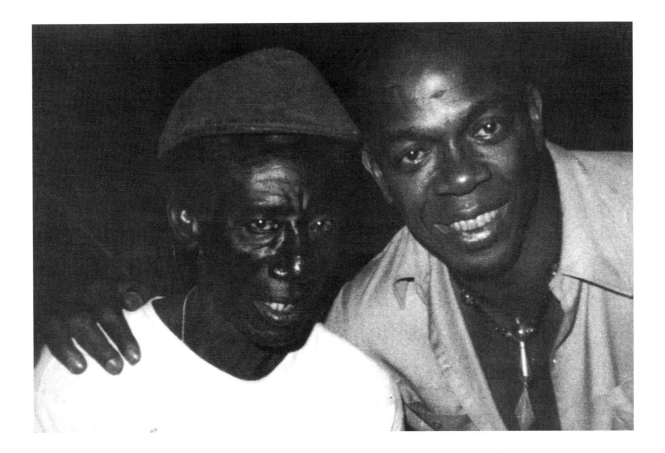

The artist with Haitian *houngan* and painter, André Pierre, Haiti, 1979.

who was then assistant to the manager of the Trinidad & Tobago Tourist Bureau, alerted me to the plans for the first Caribbean Festival taking place in San Juan, Puerto Rico in August, 1952. I applied and my wish was granted, thanks to Donald's tip and Lisa Lekes, a festival coordinator. But it was Catherine Randolph, who was in charge of the painting activity, who adopted me, loved me, loved my art, encouraged me, inspired me and introduced me to the world of pure Haitian folklore and art. She was a close friend of Raphael Tufino, one of Puerto Rico's leading painters, and Dewitt Peters of the Centre D'Art in Haiti, and her collection of Haitian art was astonishing. The first time I saw Baron Samedi, the Haitian deity of life and death—a character I played on stage in Truman Capote's *House of Flowers*,

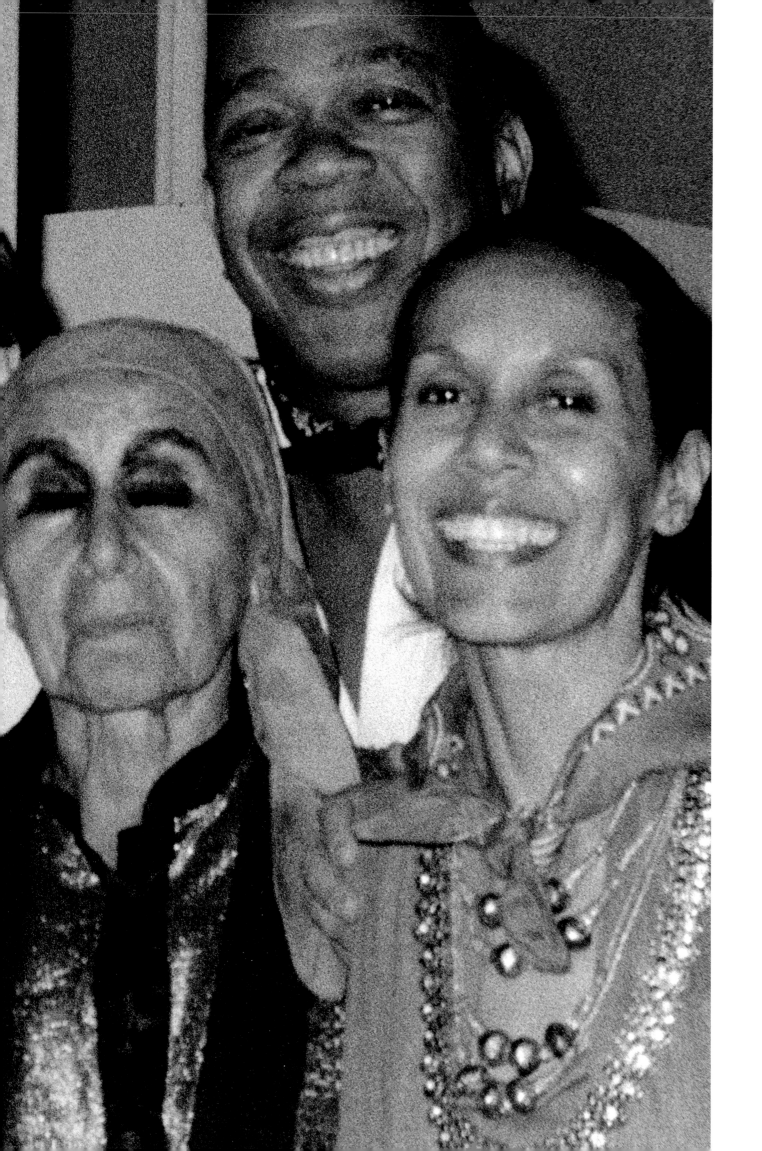

and twenty years later in the movie, *Live and Let Die*—was at a rehearsal of the Ballet Folklore of Haiti, danced by Celestin.

Through my success at the festival, I was invited to return with a smaller dance company. I packed my bags, my books and my paints and traveled with a company of five men and one woman, who all gave up their government jobs to follow me for fame and fortune. We performed in Puerto Rico and St. Thomas. I would paint and Catherine would arrange an art exhibition for me at the Attoneo in Puerto Rico where I sold quite a few of my paintings to help support the group. She had a wonderful friend named Ted Brett, a fine painter, who in turn befriended me. Since my dream was to go to America, I kept mentioning to Ted, "Oh, when I get to America I want to go to the Art Students League to study." He snapped back, "Don't you dare. The only way to learn to paint is to paint!"

After leaving the glare and color of the Caribbean sun, arriving in New York was gray and drab. It was in the early spring of 1953. The new spring leaves had not begun to dance or sing, and people wore their drab winter colors of beige, dirty brown, dull green and gray. After getting settled and learning to find my way about New York, I was recognized on the street by Horace Sutton who had been to my home in Trinidad and had seen me paint and dance. He invited me to his

The artist with painter Alice Neel in her studio, New York, 1984.

(LEFT) The artist and his wife at home with Louise Nevelson, a year before her death, New York, 1987.

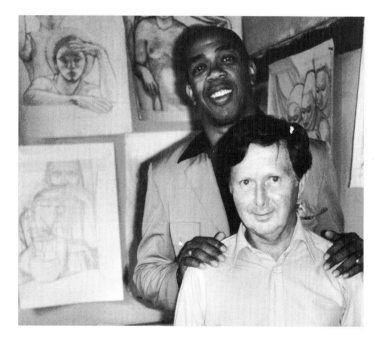

home for dinner to meet his wife, Nancy, and to meet other friends and neighbors, including Stuyvesant and Fran Van Veen who had also been to my home in Trinidad. Horace lived across from the enchanted Gramercy Park on 20th Street, and the Van Veens lived on 19th. It was an incredibly warm reception and I realized the world was very small.

Stuyvesant, who was the head of Artists' Equity, invited me to his home the following Sunday where he held a salon with other artists. I was happy to go and, to my surprise, one of my paintings hung on the wall of his home. It held a proud spot next to a Max Beckmann drawing of Stuyvesant's wife, Fran. I was literally tongue-tied because at the time I possessed the worst stammer imaginable. My only consolation was that Fran stammered as well. On Sundays their home was always filled with artists like Jacob Lawrence and his wife, Gwendolyn; Kunioshi and his wife, Sarah; and Julio De Diego (once married to Gypsy Rose Lee) —all fascinating and brilliant people. But the conversation was not only about art. The main topic was McCarthyism, for this was in the

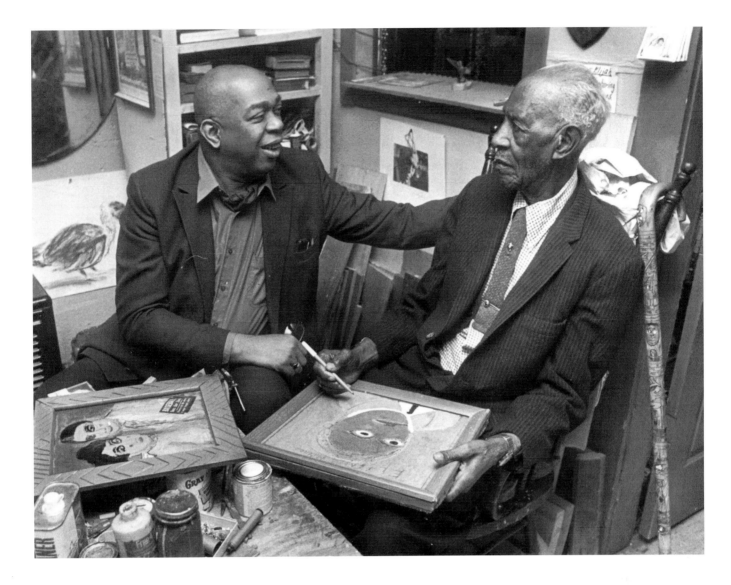

(ABOVE) Holder with artist, Elijah Pierce, North Carolina, ca. 1980.

left:
(upper) The artist, sculptor Richmond Barthé, and Henry Wheatley, New York, 1953.

(middle) The artist with painter Fritz Schölder, New York, ca. 1980.

(lower) The artist with painter George Tooker at his studio in Vermont, 1981.

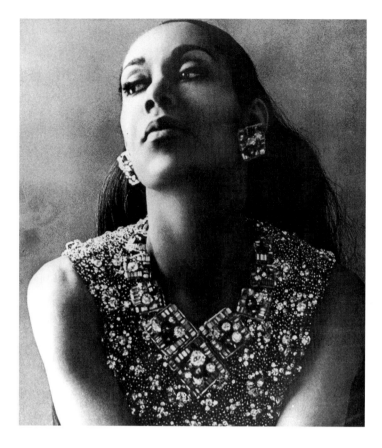

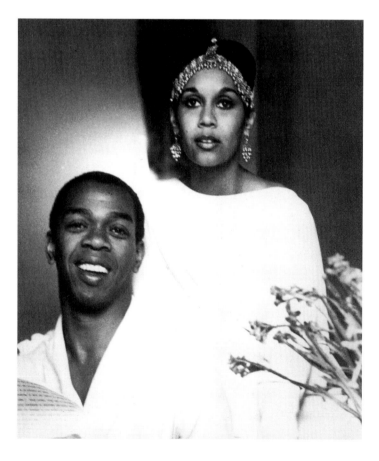

midst of the hearings. Still, it was a wonderful time for me to discover other painters whom I eventually had the good fortune to meet: George Tooker, Louise Nevelson, Alice Neel and Richmond Barthé. I met Barthé through Carl Van Vechten who was deeply involved in the Harlem Renaissance and knew every black artist, singer, and dancer in America.

I have always painted hauntingly beautiful Creole women and had the good fortune to marry one— Carmen de Lavallade. When I met Carmen it was as though she stepped out of one of my paintings. Maybe I dreamt her up. When I saw her face I died and was resurrected and she became even more beautiful after I met her and got to know her. She was and is elegant, ethereal, lyrical, gracious, feminine, strong, and a brilliant dancer and actress. After we married, she also began painting, something she had done as a child, and she sculpted, so we had much in common.

(UPPER) The artist's wife, Carmen de Lavallade, New York.
(LOWER) Carmen de Lavallade and the artist in Paris, 1965.
(RIGHT) The artist and his family, New York, November, 1957.

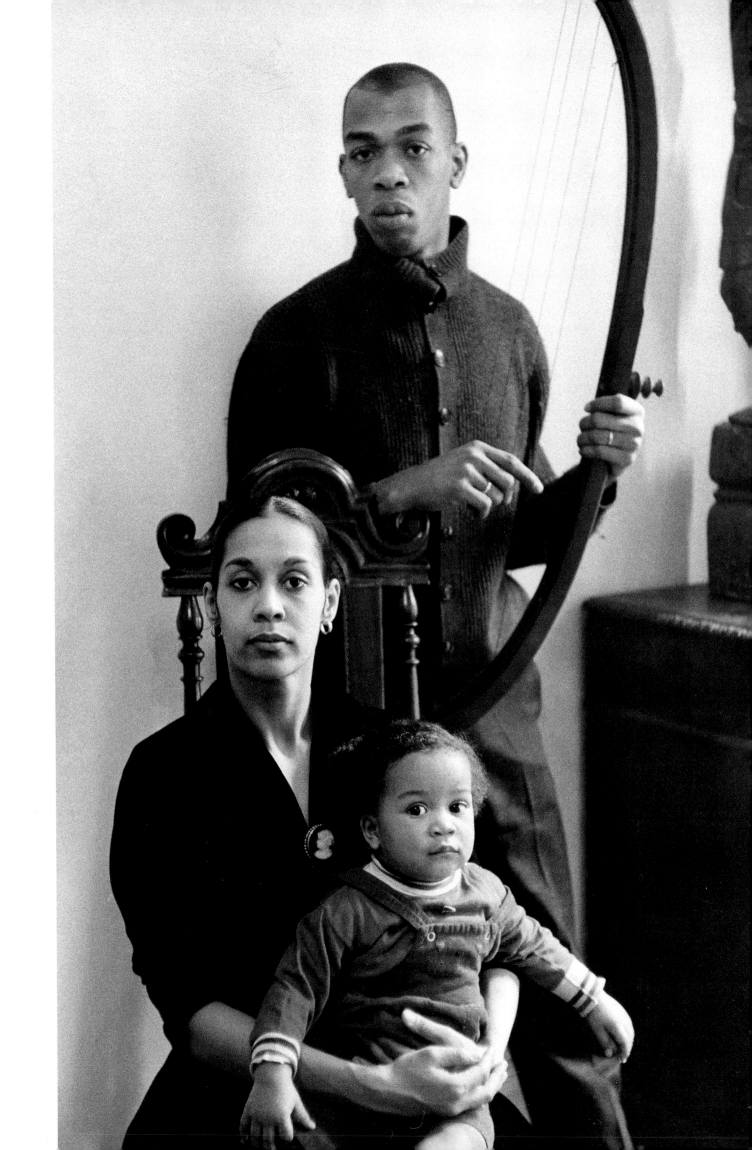

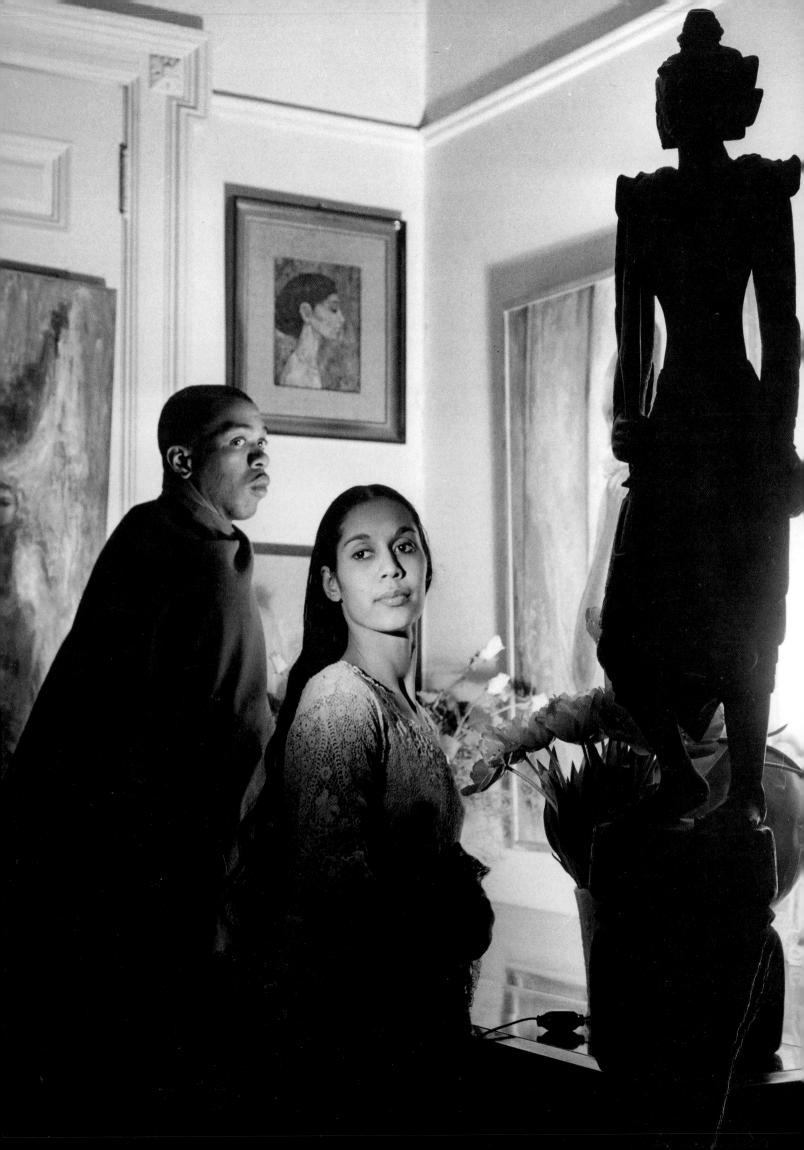

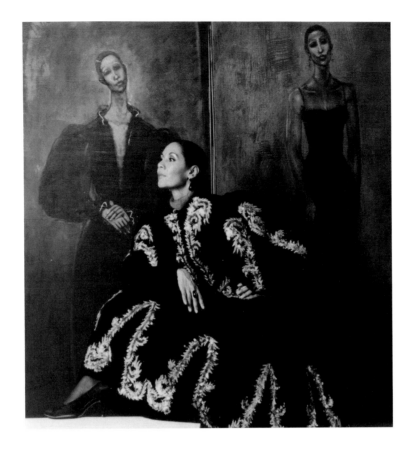

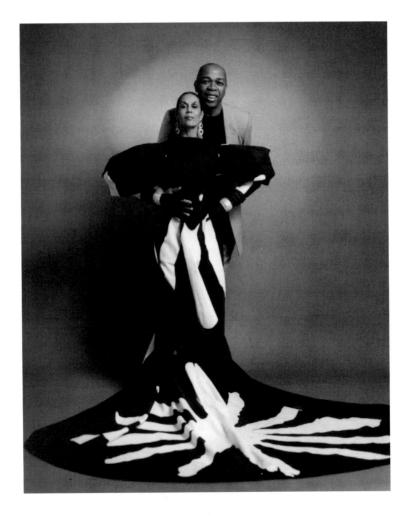

(FAR LEFT) The artist and his wife, Carmen, at home, New York, 1957.

(UPPER) Carmen de Lavallade in dress designed by Geoffrey Holder, New York, 1980.

(LOWER) Carmen de Lavallade in costume designed by Geoffrey Holder, New York, 1982.

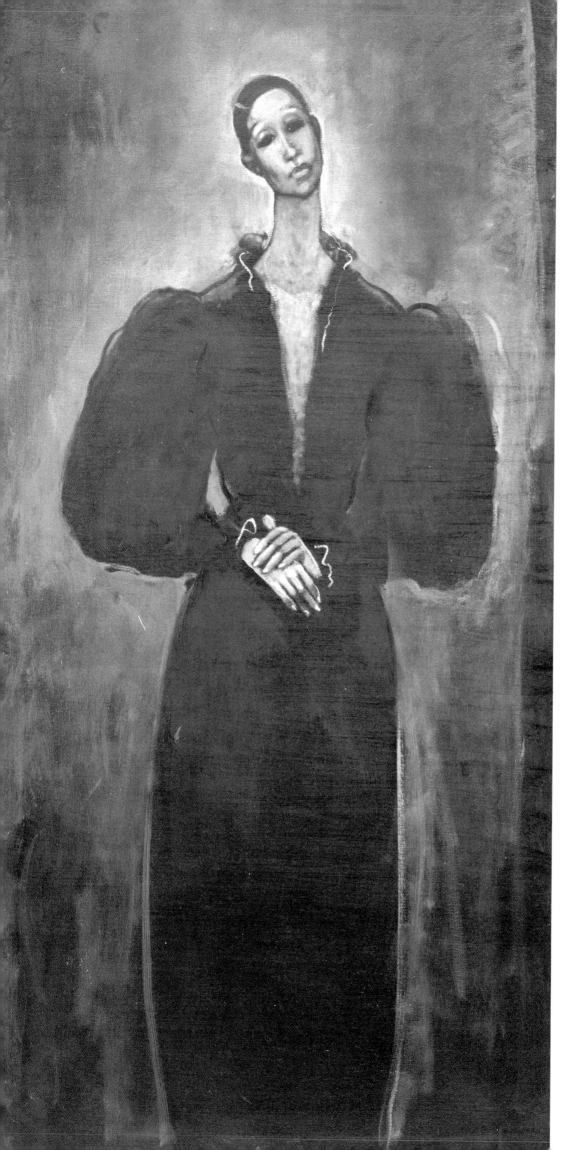

Carmen de Lavallade,
1982, oil.

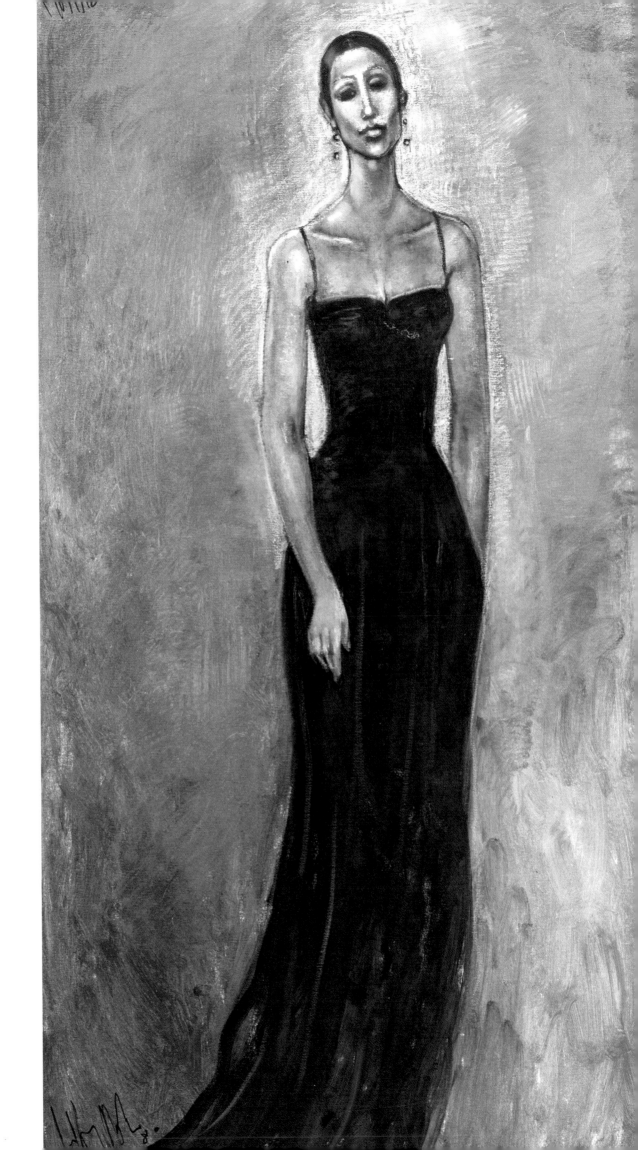

Carmen de Lavallade,
1982, oil.

51

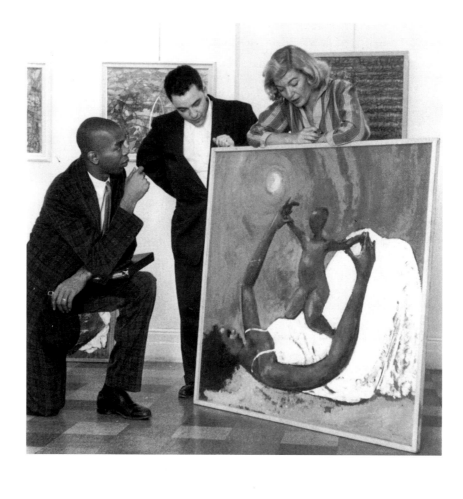

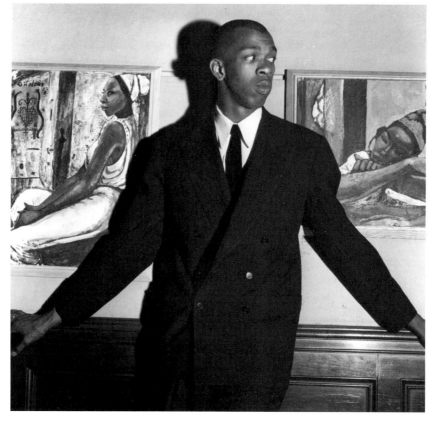

I had met the founder of *Cue* magazine, Mort Glankoff, who became a great fan when he saw me perform, and a bigger fan when he saw my paintings. He arranged my first major one-man show in New York at the Barone Gallery on East 52nd Street. I planned the show to open a month after my Broadway debut in *House of Flowers*. I never wanted to be known as an actor/dancer who paints. Ironically, painting has always been how I've earned my living.

I encountered Leonard Hanna who reintroduced himself to me in New York, and bought another painting to add to his collection. I was astounded to find my work nestled among those by Modigliani, Monet, Renoir and Degas. All this inspired me to paint and paint and paint, for my paintings were being placed in such good company. Many of my New York friends supported my application for a Guggenheim Fellowship, as did Ronald and Marietta Tree (who had bought two of my paintings at an exhibition at the Barbados Museum when I was seventeen) and Samuel Barlow whose strong

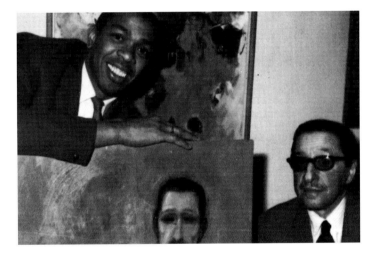

(ABOVE) The artist with composer Harold Arlen, New York, 1964.

(UPPER LEFT) The artist with gallery owner Laura Barone and movie director and collector Harvey Hart, Barone Gallery, New York, 1959.

(LOWER LEFT) The artist with his paintings at the Barone Gallery, New York, 1958.

(ABOVE) Carmen de Lavallade and Geoffrey Holder being presented to Paris by Josephine Baker, 1964.

(RIGHT) The artist painting in the garden of Jacques Sigurd's home, Paris, 1965.

influence had made that exhibition possible.

It was not until Paris, though, that my artistic senses exploded. After dancing there with Josephine Baker, I met a wonderful film writer named Jacques Sigurd who took me under his wing. Many things he said served to free my mind, allowing me to take flight as a painter, bringing another level of truth to my work. He gave me Paris on a golden platter.

I lived in Paris on Rue de Seine, right around the corner from Rue des Beaux Arts where all the galleries and art bookshops are. My whole apartment smelled of turpentine and oil paints. It became my studio and I painted until the wee hours of the morning. Jacques acted as the Pope, and I swore that I was Michelangelo. Being far from America and having to write letters, which I hated, helped me develop a sure hand for line drawings. Jacques acquired so many of my paintings while my friend Regis Pagniez, now Publications Director at

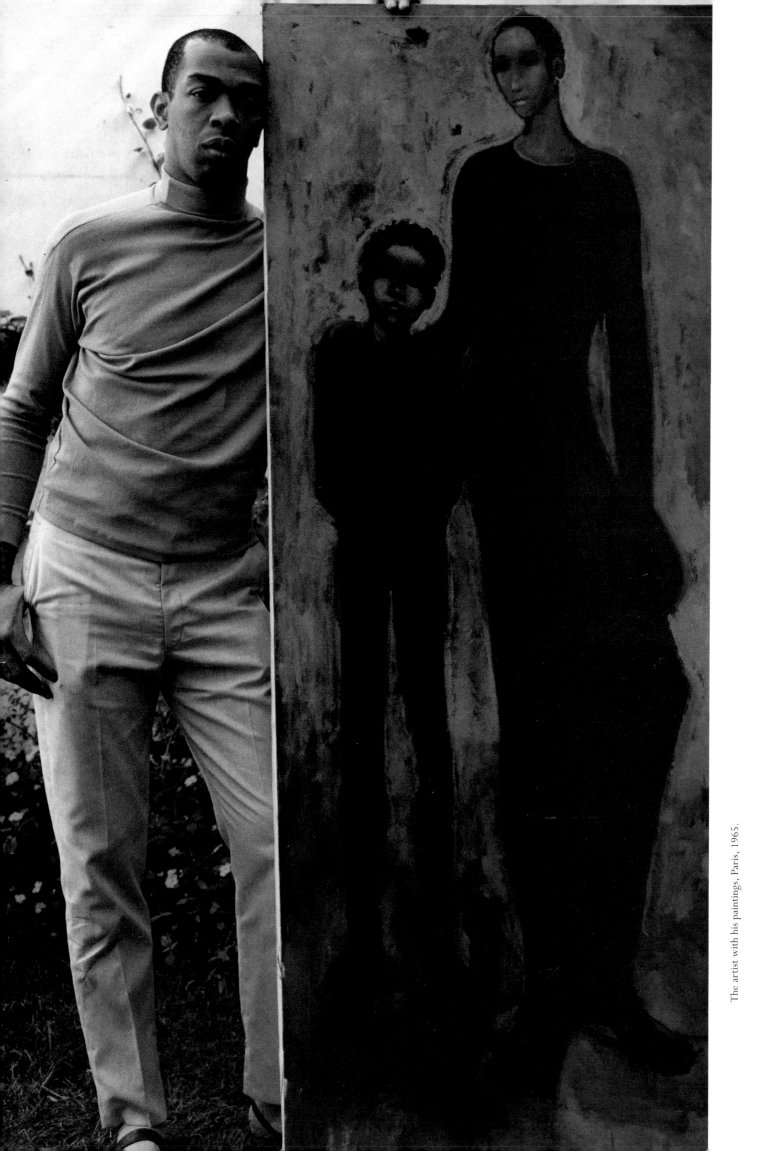

The artist with his paintings, Paris, 1965.

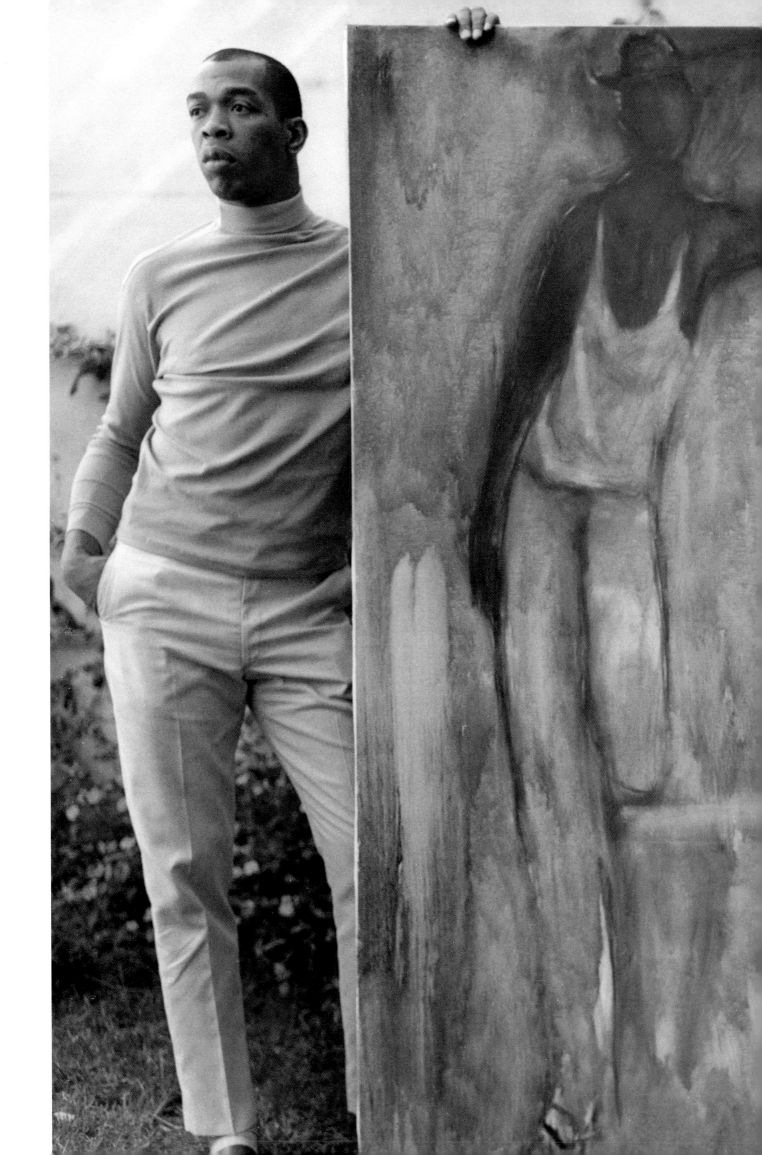

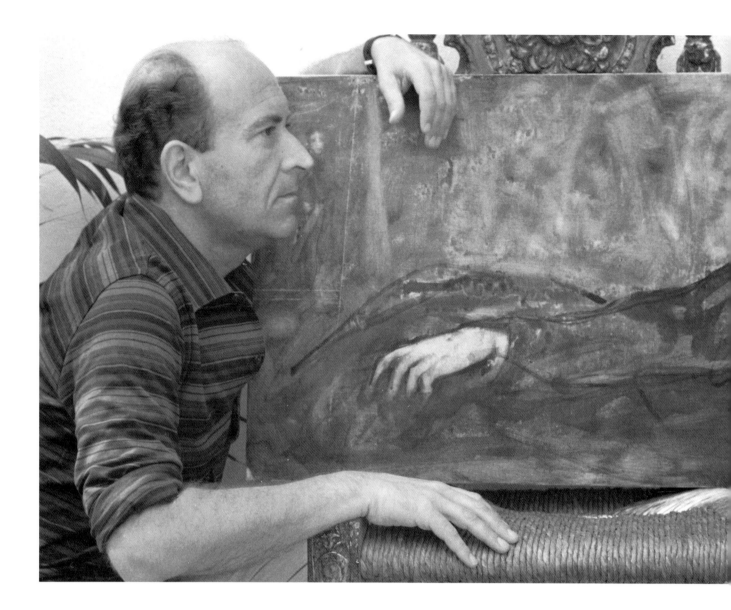

Elle, supplied me with a charge account at an art supply store on Rue des Beaux Arts, and I was in heaven!

Paris is like my second home. I love the people, the incredible light which plays havoc on the eye and makes everything fluorescent, the constant exposure to art, and the civilized way of life where you can find your space without having anyone invade it.

Mexico is another magical place to me. While I was there I had the chance to acquire some art—what art I could afford, that is—including some Diego Rivera drawings and an enormous collection of Miguel Covarrubias drawings, watercolors and caricatures of

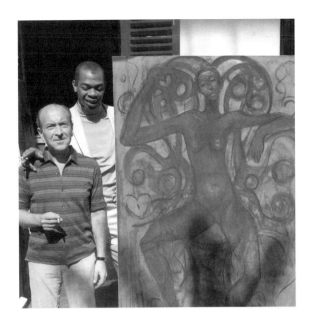

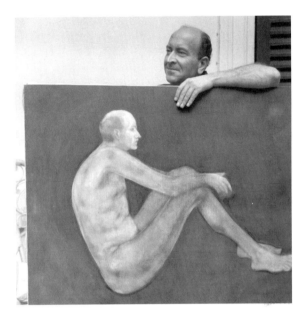

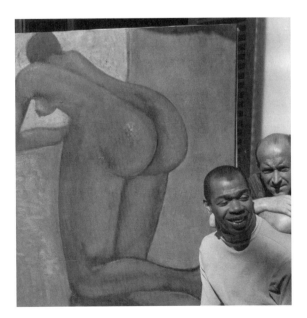

(above) Jacques Sigurd with his portrait by Geoffrey Holder,
Paris, 1965.

(RIGHT) The artist and Jacques Sigurd, Paris, 1965.

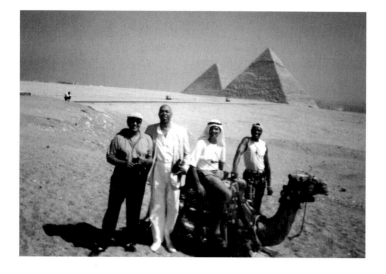

Bali, Harlem, and Mexico. Driving through the Mexican countryside, it was thrilling to see the wonderful magenta tree blossoms against the earth, and the people in the attire of their villages. I enjoyed watching people visit their local museums to see themselves in the art, the true mirror of their lives. I was angry at myself for not having time to draw or sketch the dancers from the Ballet Folklorico de Mexico while I was there choreographing a ballet for them. I was happy, however, to meet Tamayo and his wife at the home of my friend Robert Brady, whose walls were filled with the art of Mexican masters. When I had to design costumes for the Broadway show *Timbuktu*, I chose to spend ten days in

left:
(UPPER) The artist with His Royal Highness Prince Abdul Elah al-Sa'ud, Gildo Nicolo Spadoni, and George Patterson, Egypt, 1992.

(MIDDLE) The artist in Egypt, 1992.

(LOWER) The artist in Tokyo, Japan, 1984.

right:
(UPPER) The artist and His Royal Highness, Prince Abdul Elah al-Sa'ud, with his portrait.

(LOWER) The artist and his wife, Carmen, in Monte Carlo, 1980.

The artist's father, Arthur Holder, Trinidad, 1950.

The artist's mother, Louise Holder, Trinidad, ca. 1920.

Mexico for inspiration because I would be able to see the beauty around every corner and in the bazaars and churches.

Wherever I travel—Egypt; Haiti; Savannah, Georgia; Martinique; Guadeloupe or Japan—I become immersed in that world and in its art, culture, and mythology. This total absorption inspires me to paint specific subjects. We are just here to record life the way we see it, or would like to see it, the way it might have been, or the way it is. I know that I have been blessed, that I chose my mother and father—to have been born into that very family—that I chose Boscoe and Kenneth as my brothers, Marjorie and Jean as my sisters. To me, it was the perfect home—the eye of an artistic storm that engulfed me.

G.H.

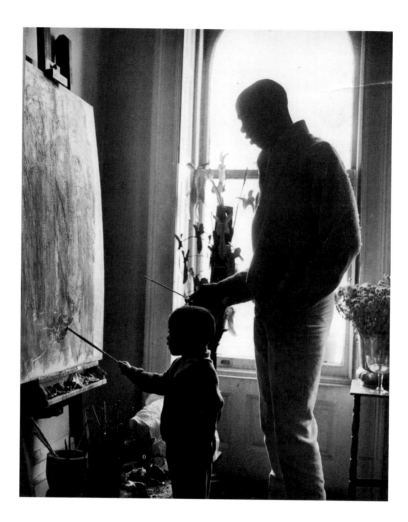

(ABOVE) The artist and son, Leo, together in studio, New York, 1961.

(RIGHT) The artist and his father, Arthur Holder, New York, 1956.

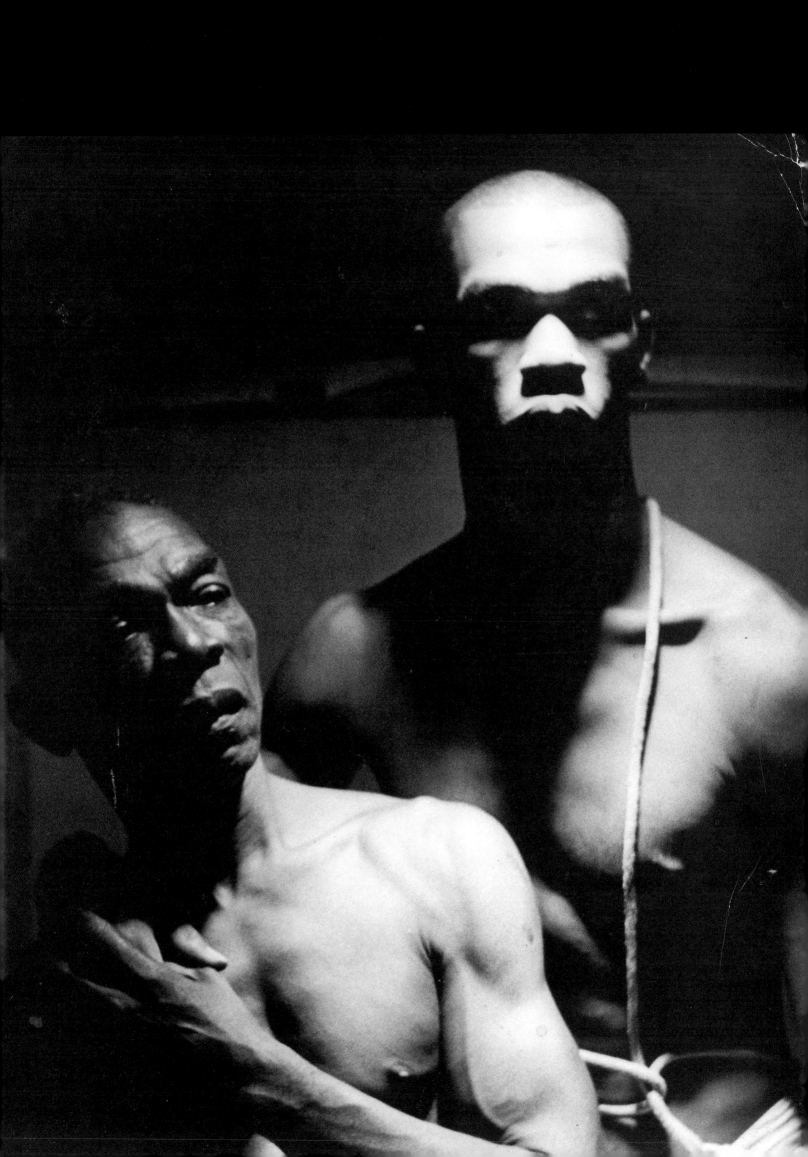

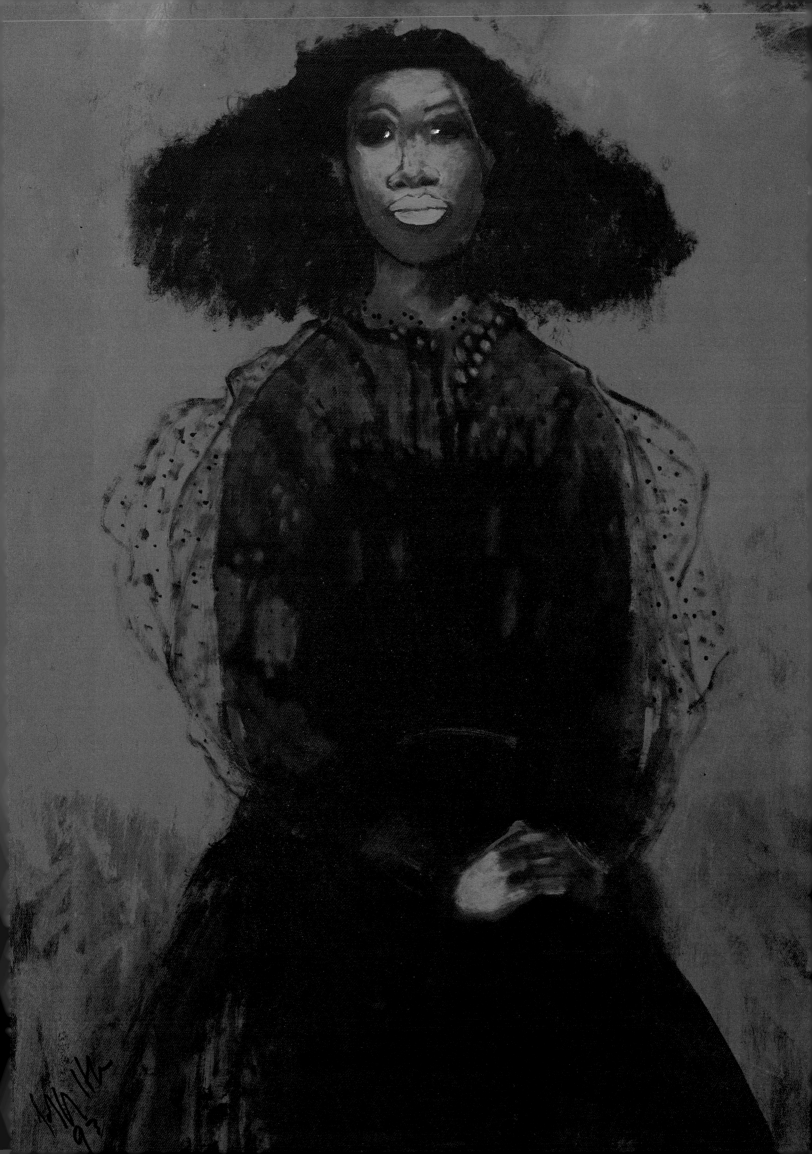

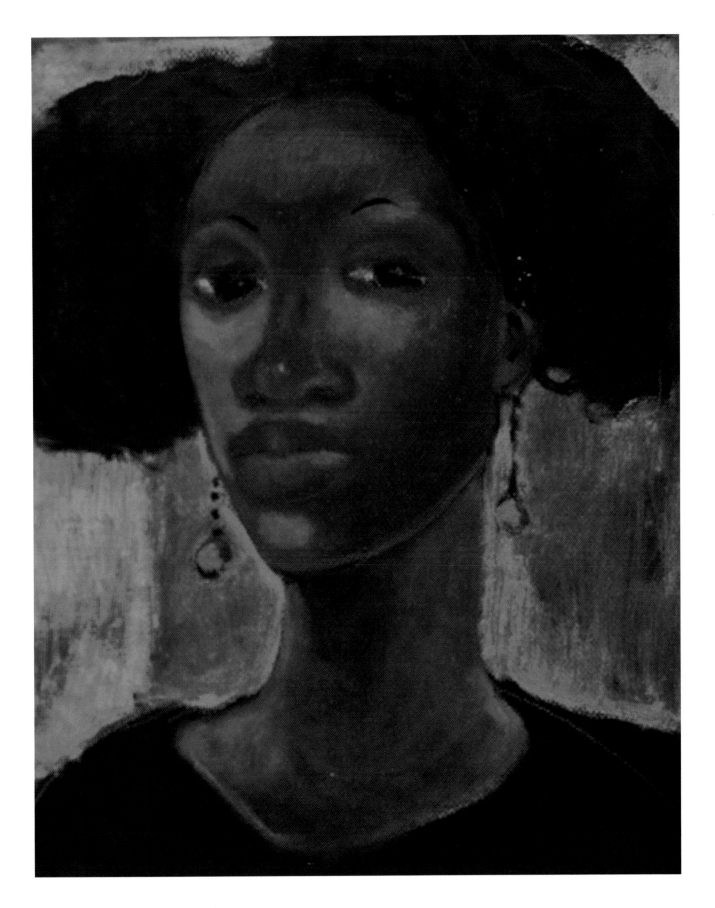

(ABOVE) *Red Earrings*, 1985, oil, 10 x 8 inches.
(LEFT) *Woman in a Black Lace Dress*, 1992, oil, 30 x 23 inches

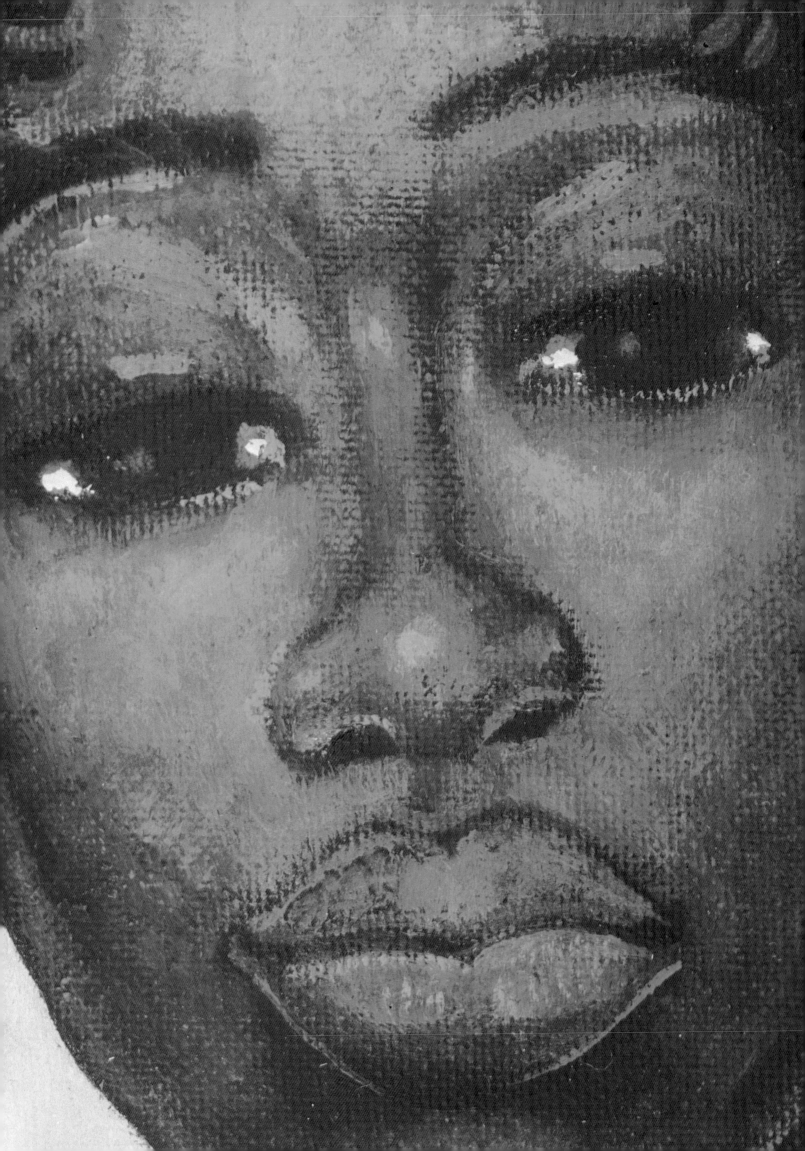

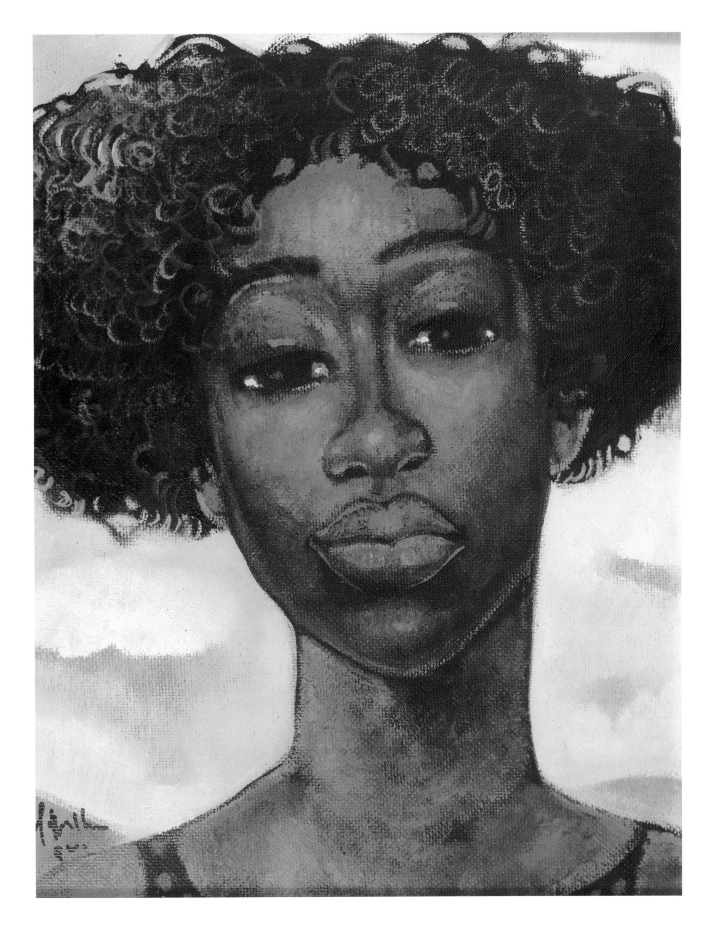

Head of Girl, 1992, oil, 10 x 8 inches
(LEFT) *Head of Girl* (detail), 1992, oil, 10 x 8 inches

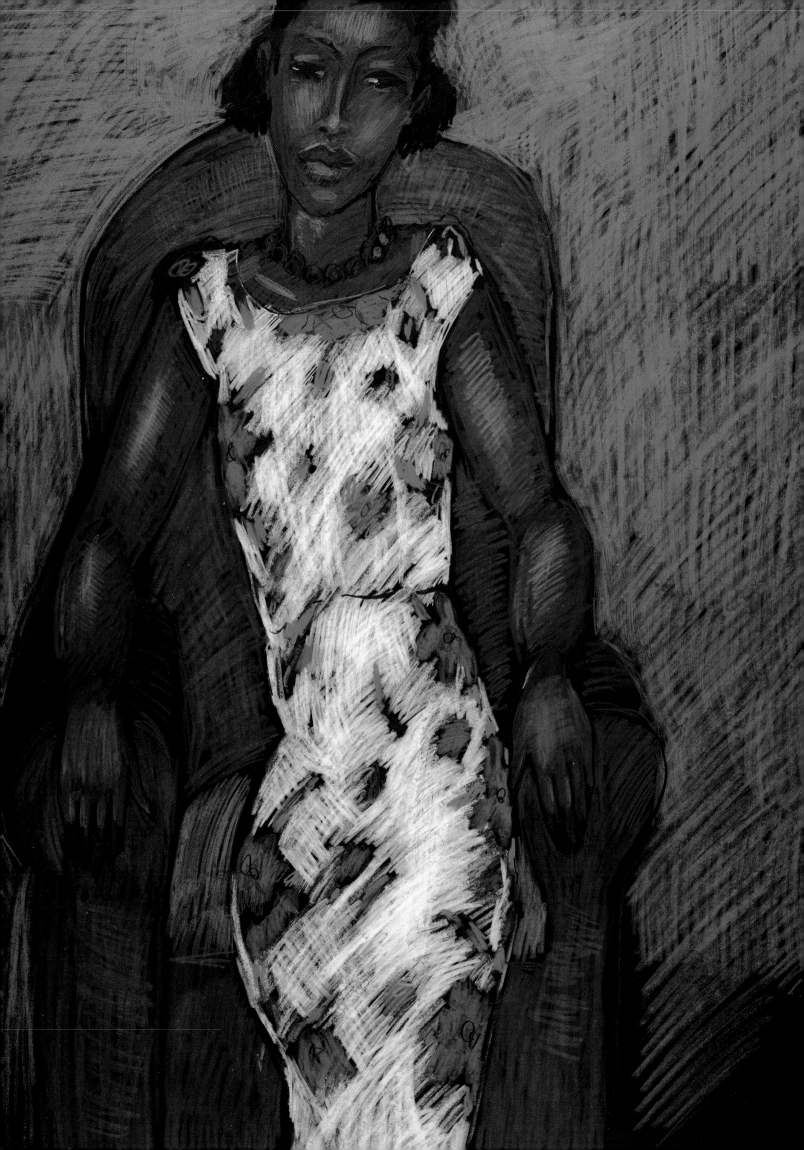

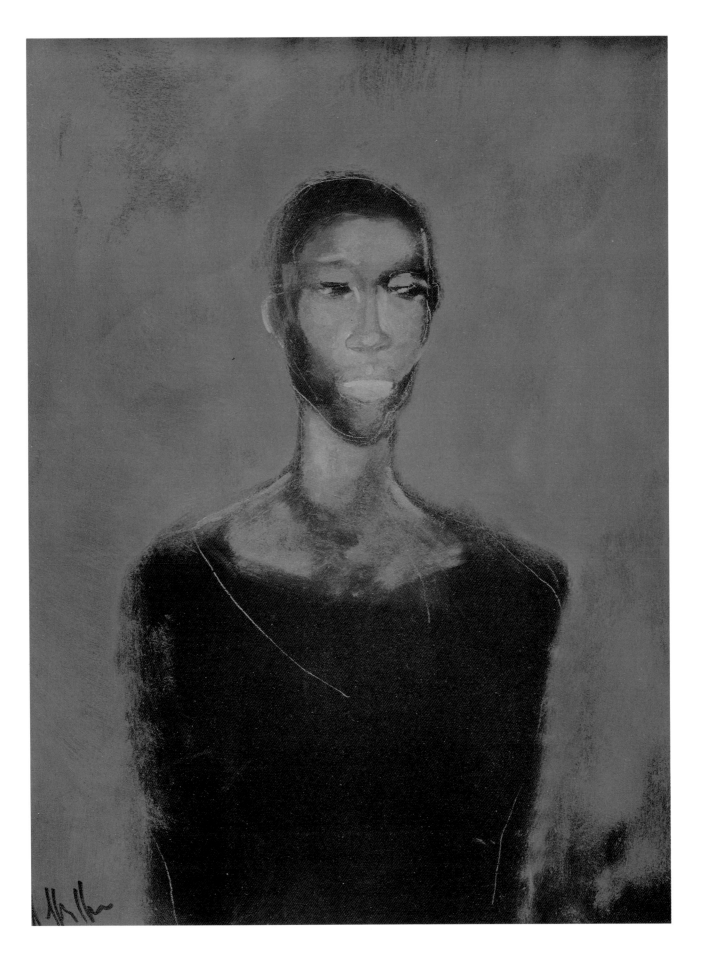

(ABOVE) *Man in Black*, 1991, oil, 16 x 12 inches.
(LEFT) *Seated Woman in White Flowered Dress*, 1989, color
pencil, 30 x 24 inches. Collection: Regis Pagniez.

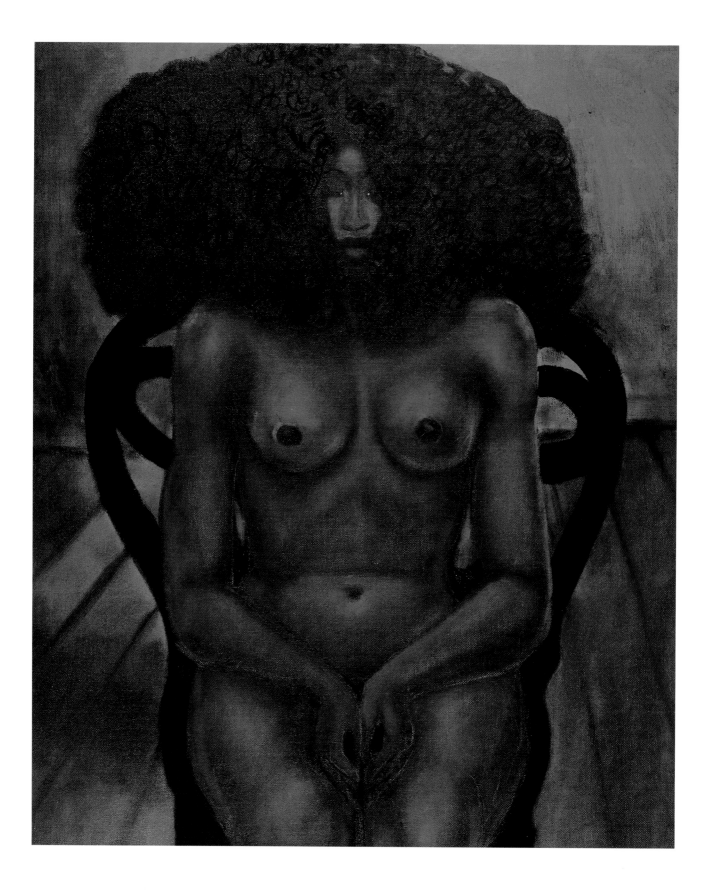

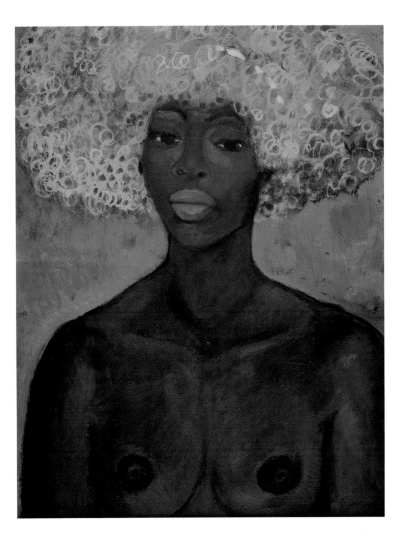

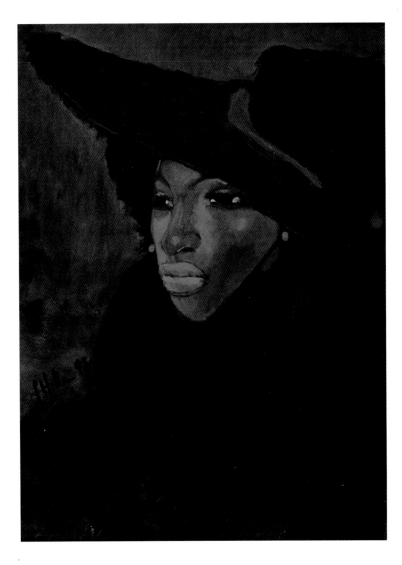

(LEFT) *Seated Nude*, 1992, oil, 24 x 20 inches.

(UPPER) *Girl in Blonde Wig*, 1992, oil, 18 x 15 inches.

(LOWER) *Black Woman in Black,* 1991, oil, 16 x 12 inches.

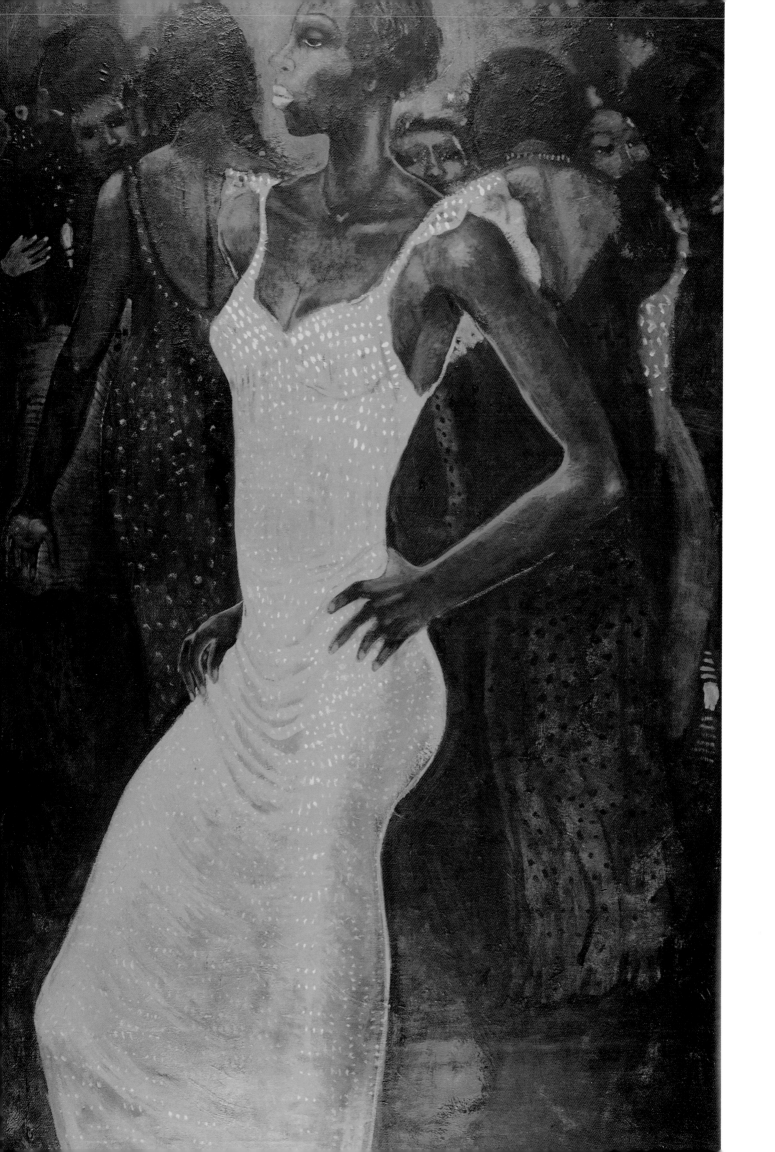

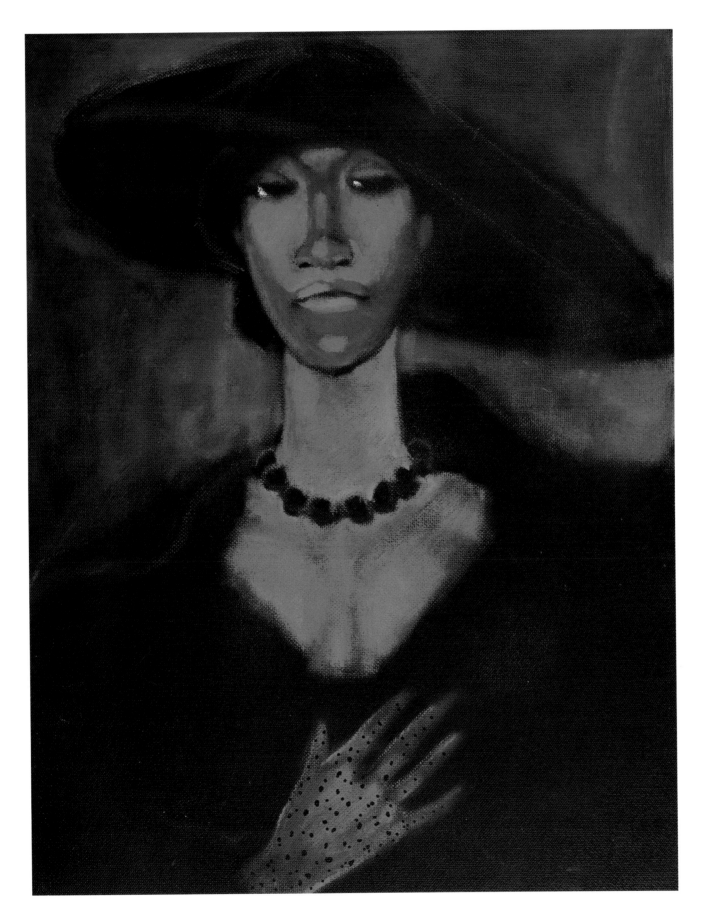

(ABOVE) *Dotted Glove,* 1991, oil, 16 x 12 inches.

(LEFT) *New Shocking Pink Dress*, 1992, oil, 60 x 40 inches.

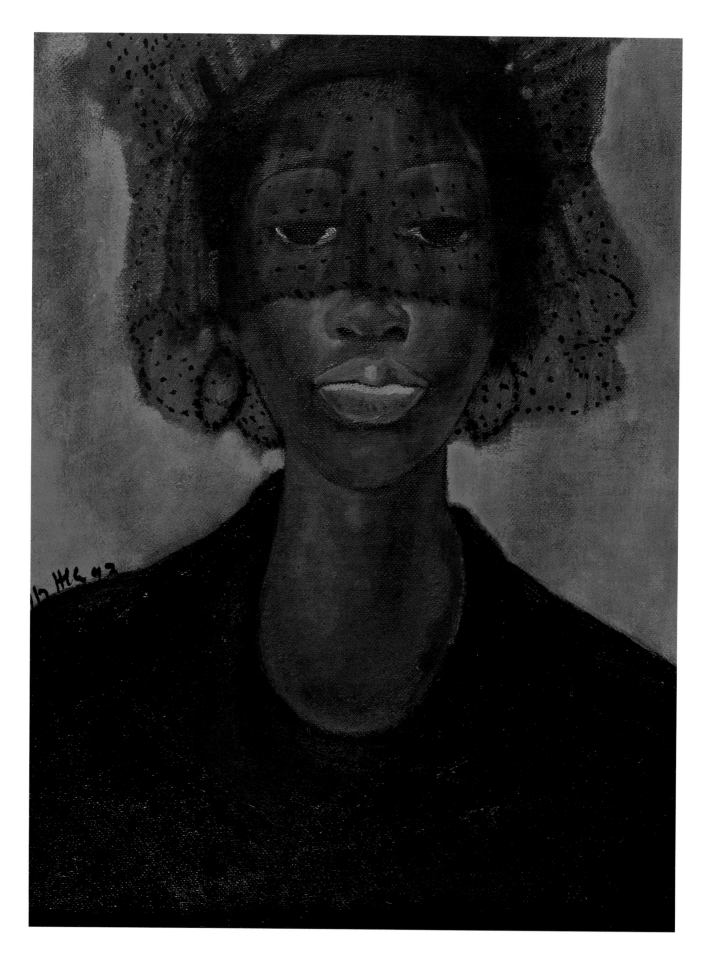

Veiled, 1992, oil, 16 x 12 inches.

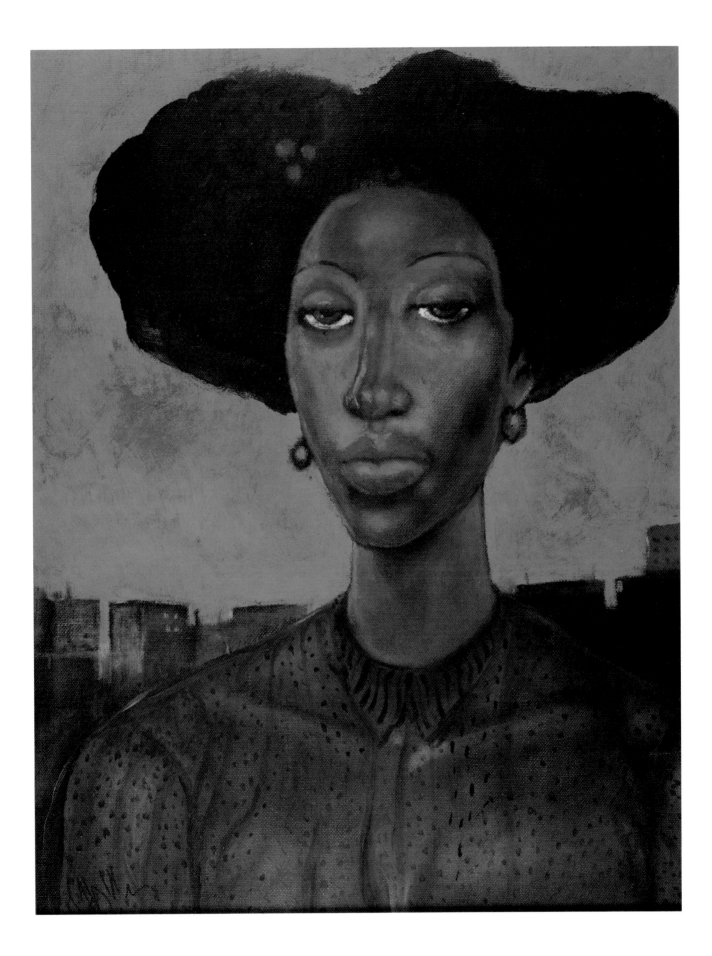

New York Beauty, 1992, oil, 18 x 14 inches.

Botanical Gardens I, 1982, oil, 60 x 36 inches. (RIGHT) *Botanical Gardens II*, 1982, oil, 60 x 36 inches. Collection: Mr. and Mrs. Don Buchwald.

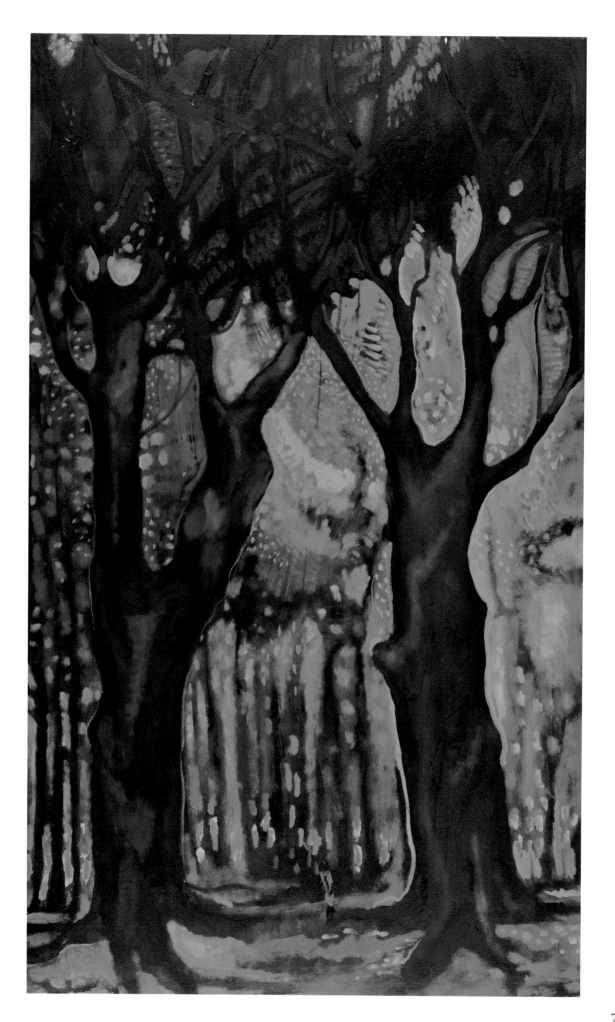

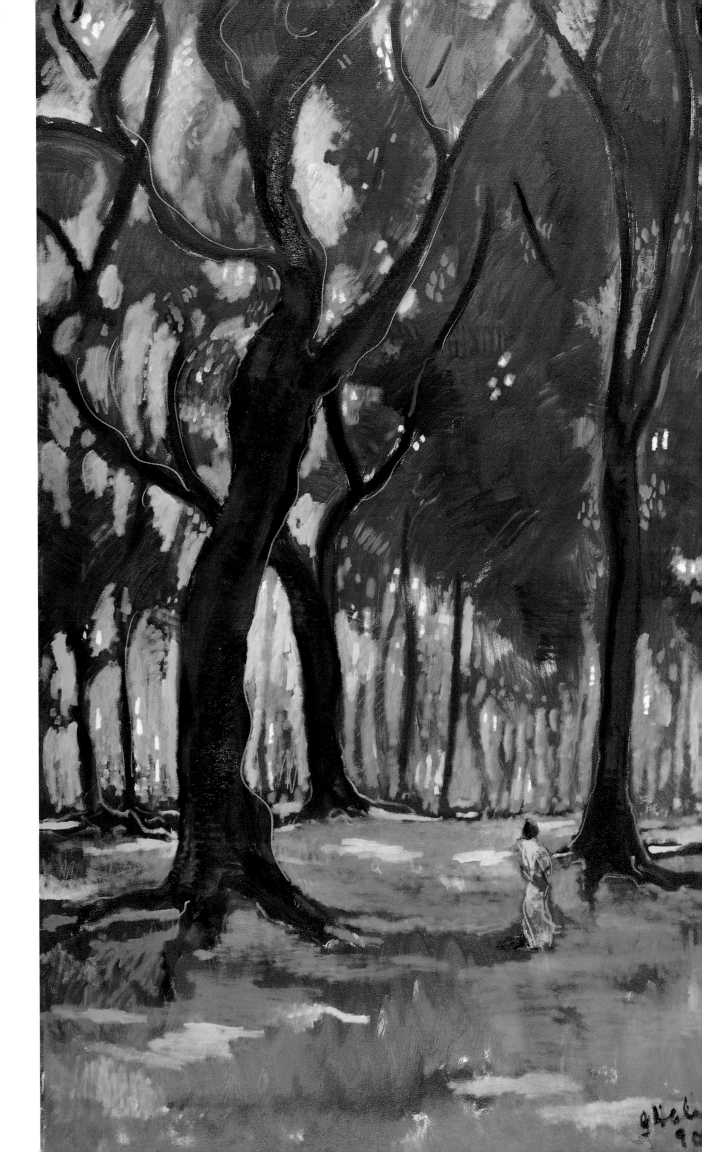

79

Callalillies, 1989, oil, 23 x 30 inches.
Collection: Barbara Johnson.

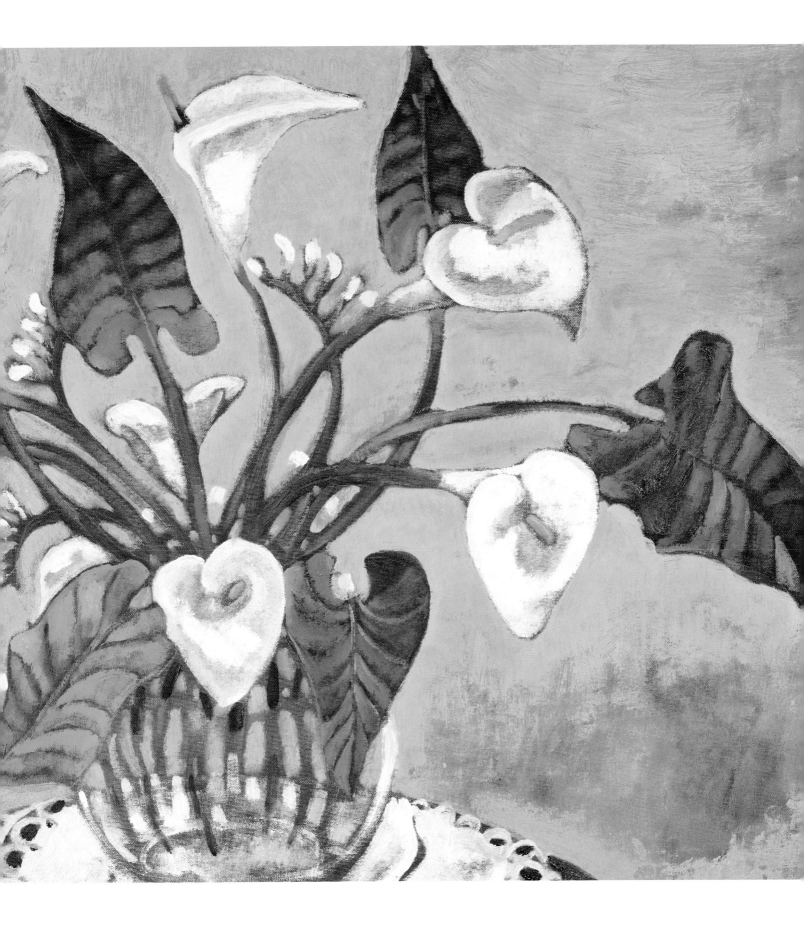

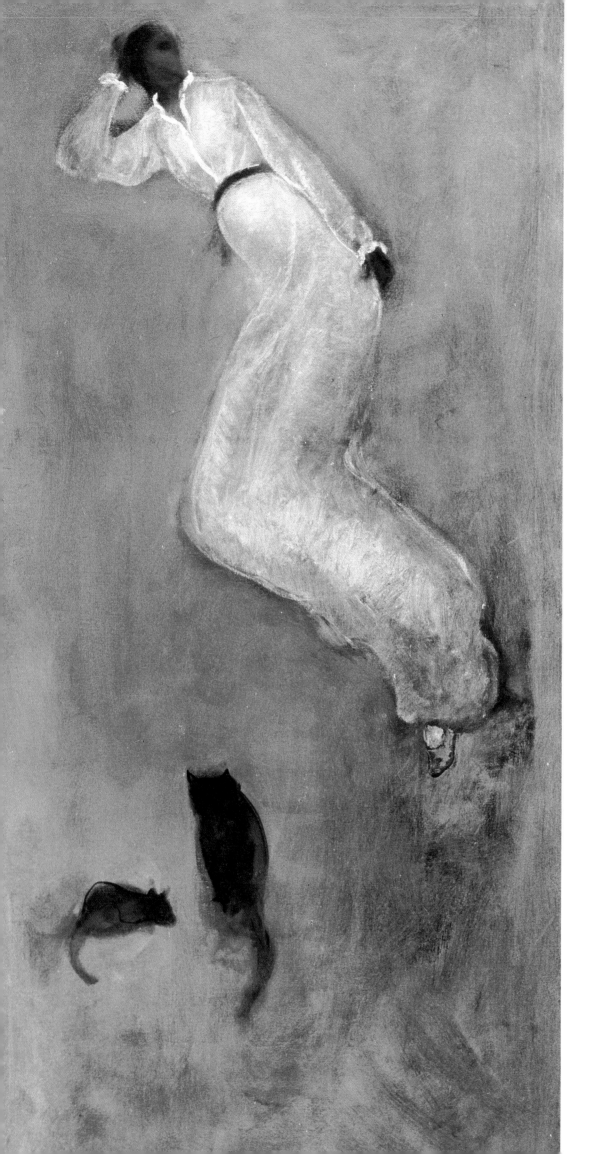

Lady with Cats, 1962, oil.

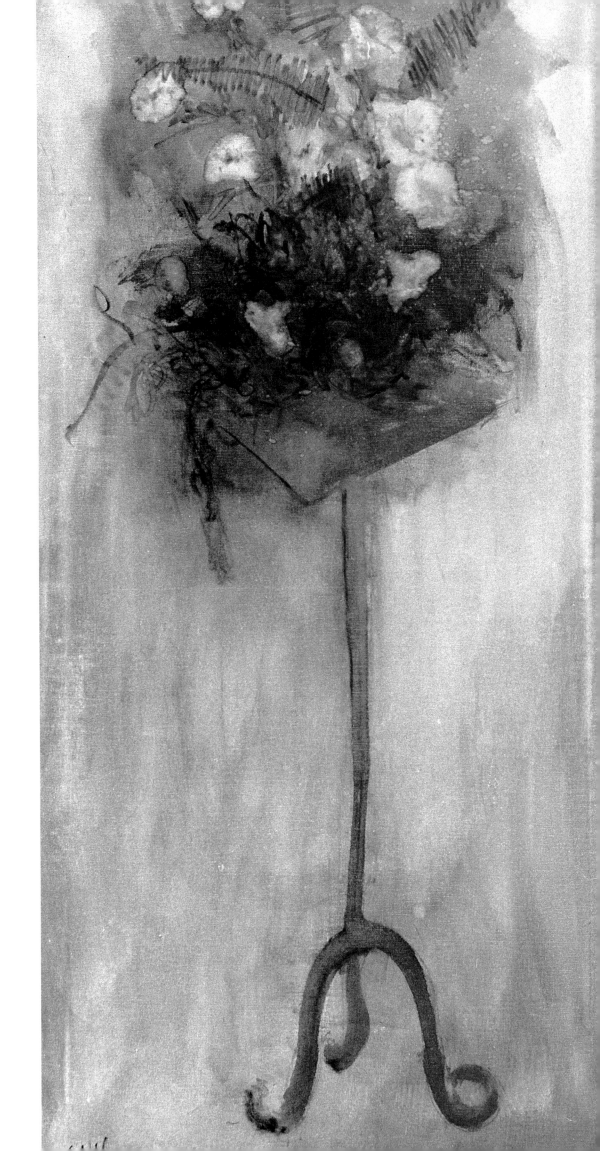

Flowers, ca. 1960, oil.

83

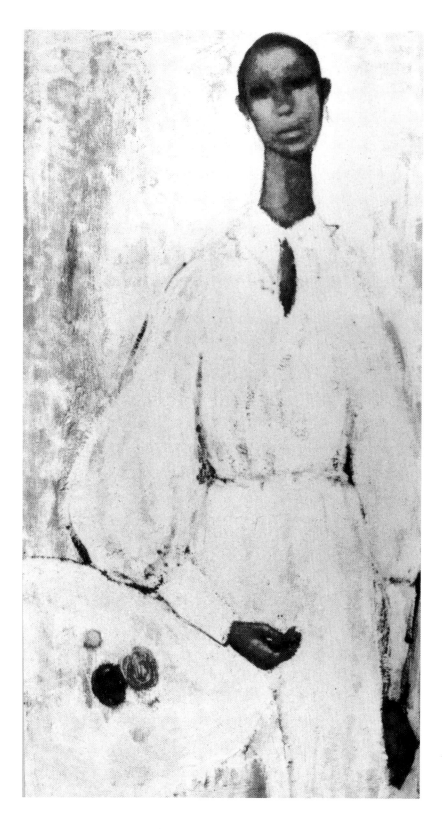

Girl in White, 1968, oil.

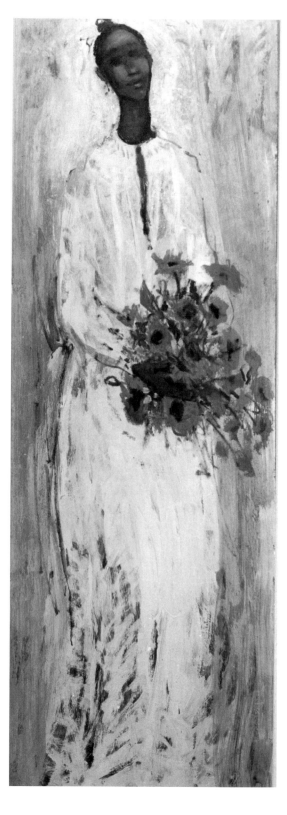

Bride, 1960, oil.

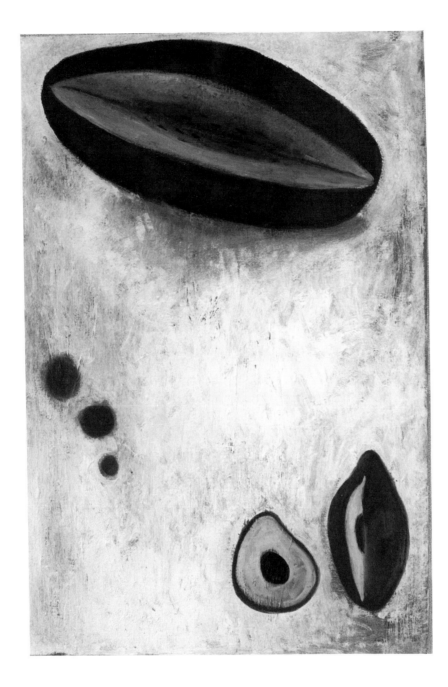

Fruit, ca. 1960, oil.

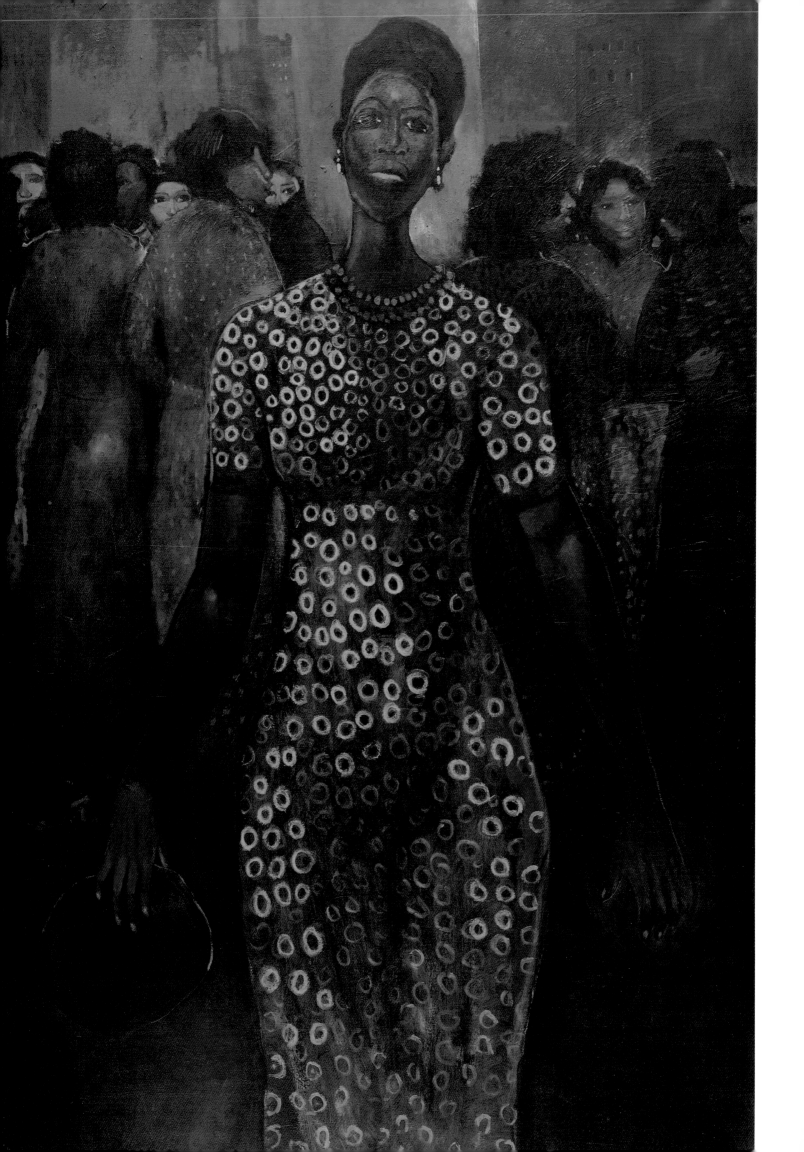

(LEFT) *On Her Way Home*, 1992, oil, 60 x 40 inches.

(LOWER) *Bitching*, 1992, oil, 23 x 30 inches.

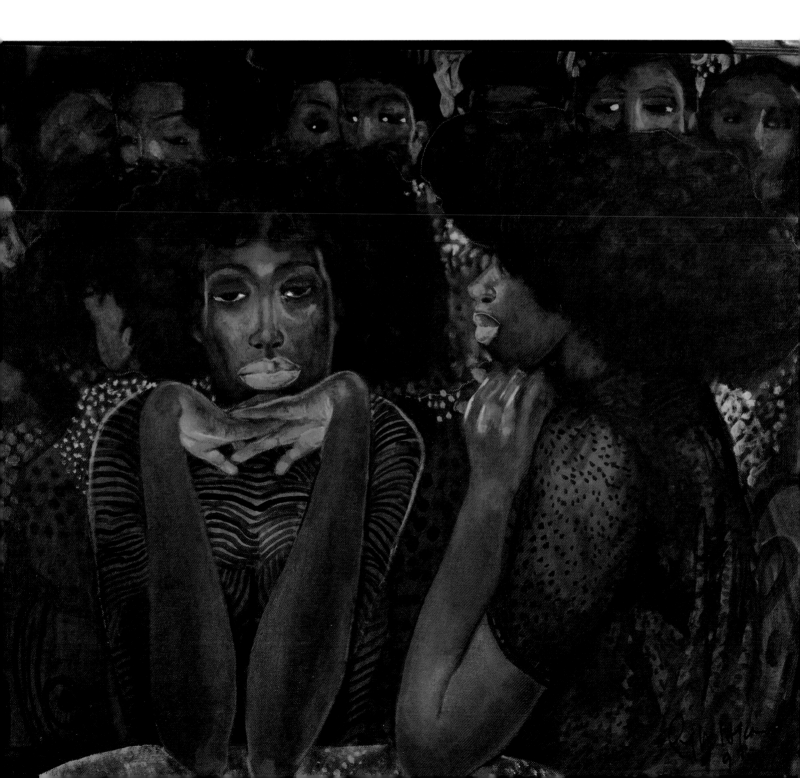

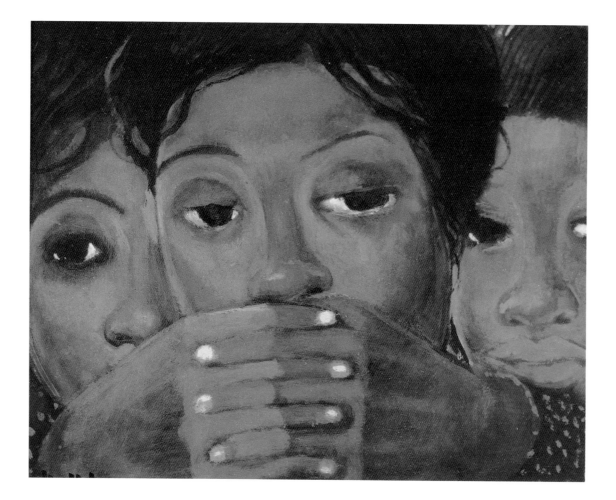

Study of Three Women, 1992, oil, 8 x 10 inches.

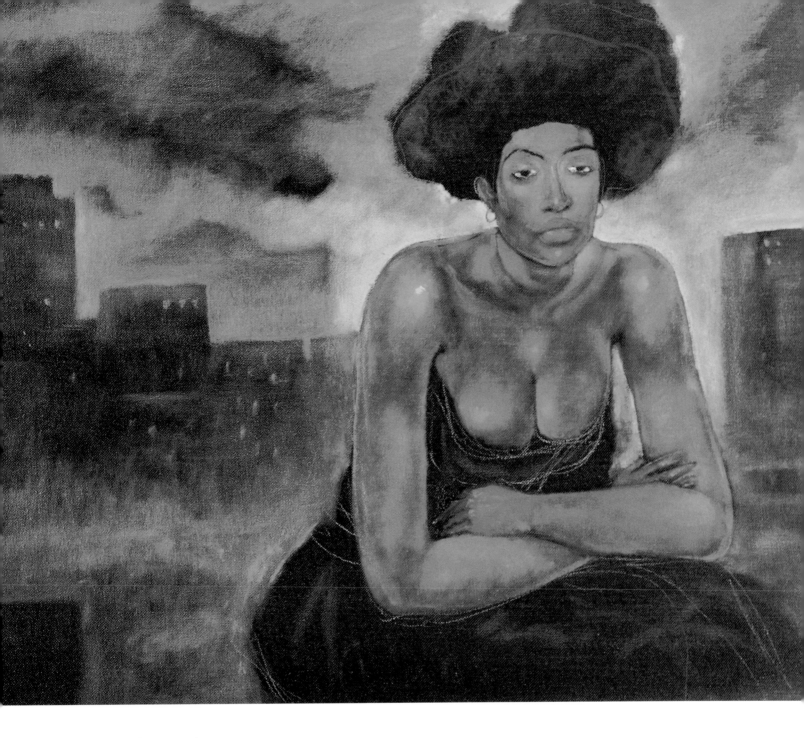

Twilight, 1991, oil, 20 x 24 inches

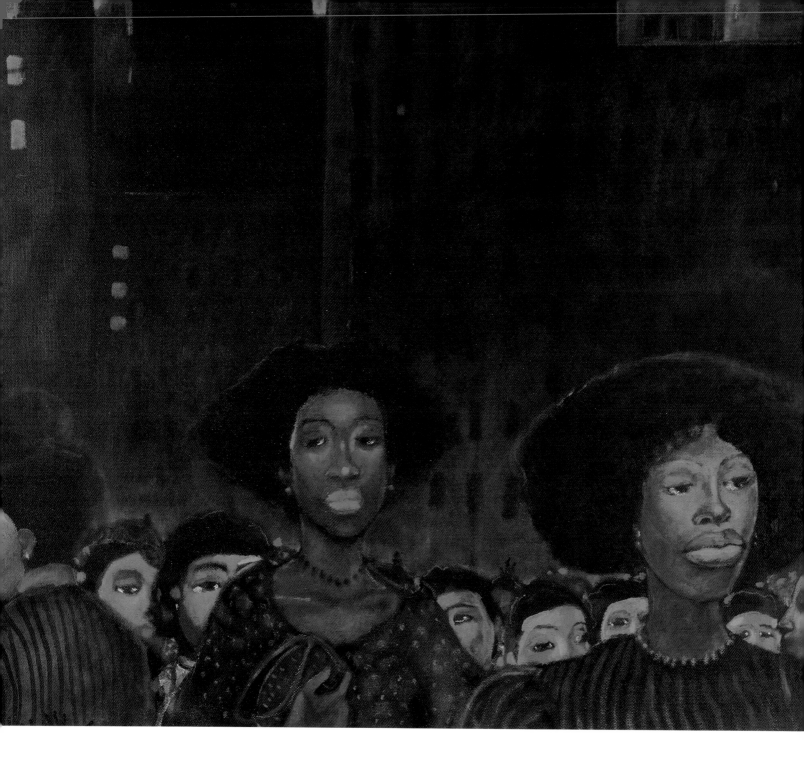

After Work I, 1992, oil, 20 x 24 inches.

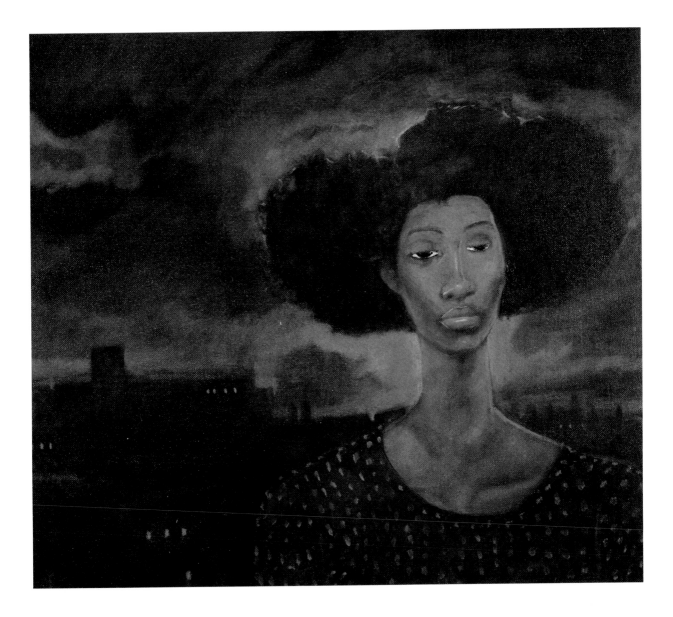

Setting Sun, 1992, oil, 20 x 24 inches.

Reclining Man, 1985, color pencil, 23 x 29 inches.

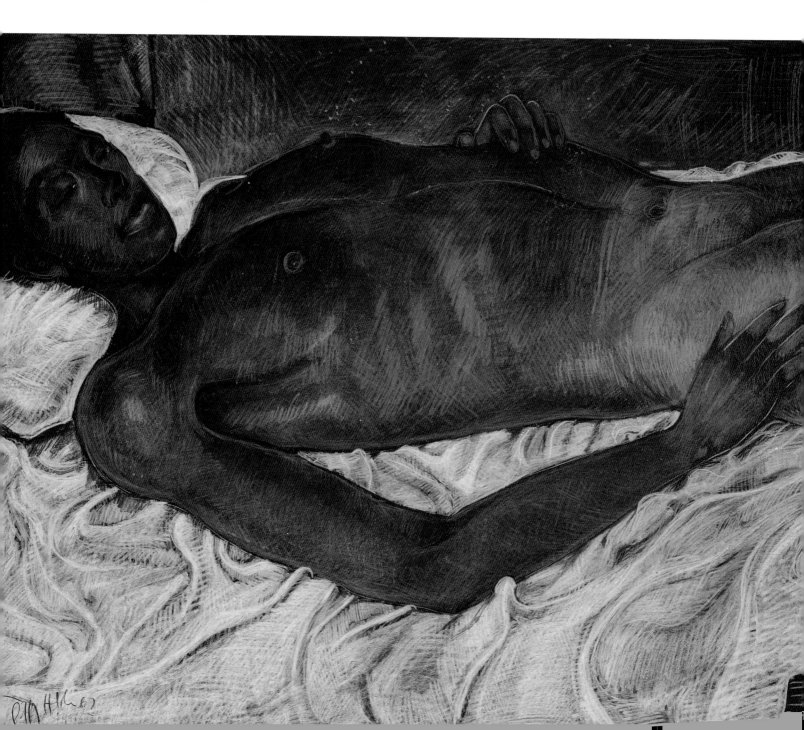

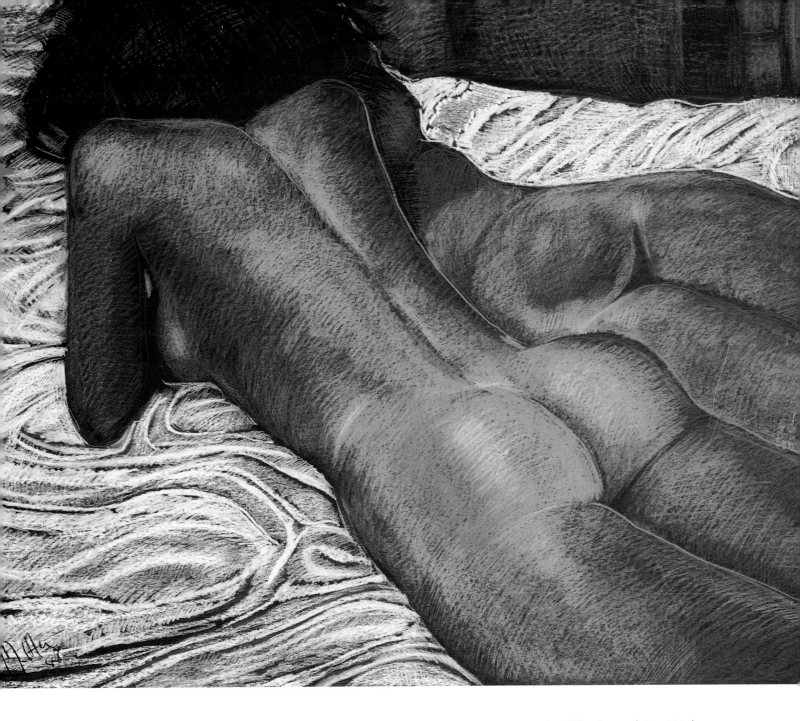

Friends I, 1985, color pencil, 24 x 30 inches.

93

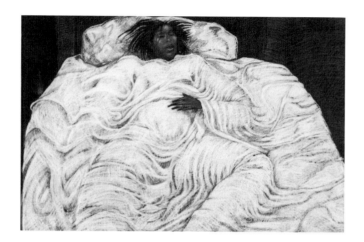

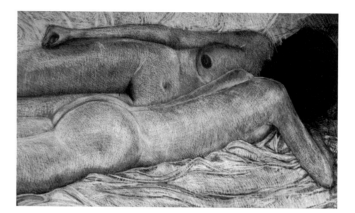

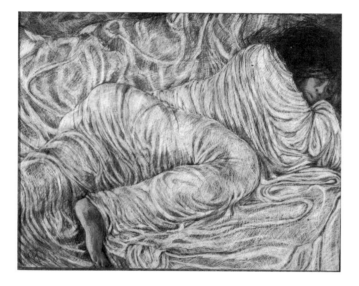

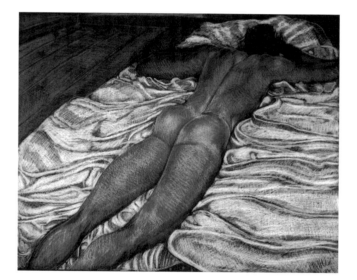

Slumber, 1983, color pencil.

Resting, 1983, color pencil.

Friends III, 1983, color pencil.

Summertime, 1983, color pencil.

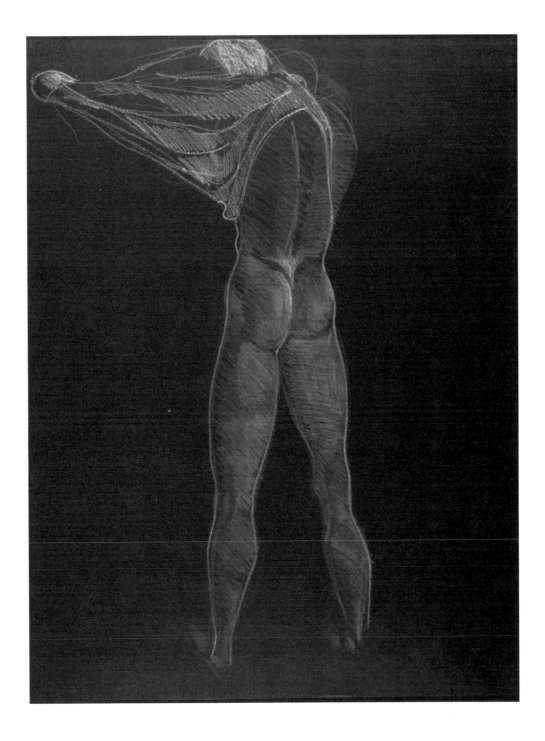

Undressing Study, 1985, color pencil, 29 x 23 inches.

(BELOW) *Swimmers III*, 1983, color pencil, 35 x 46 inches.

(UPPER RIGHT) *Swimmers I*, 1983, color pencil, 36 x 48 inches.

(LOWER RIGHT) *Swimmers II*, 1983, color pencil, 36 x 46 inches.

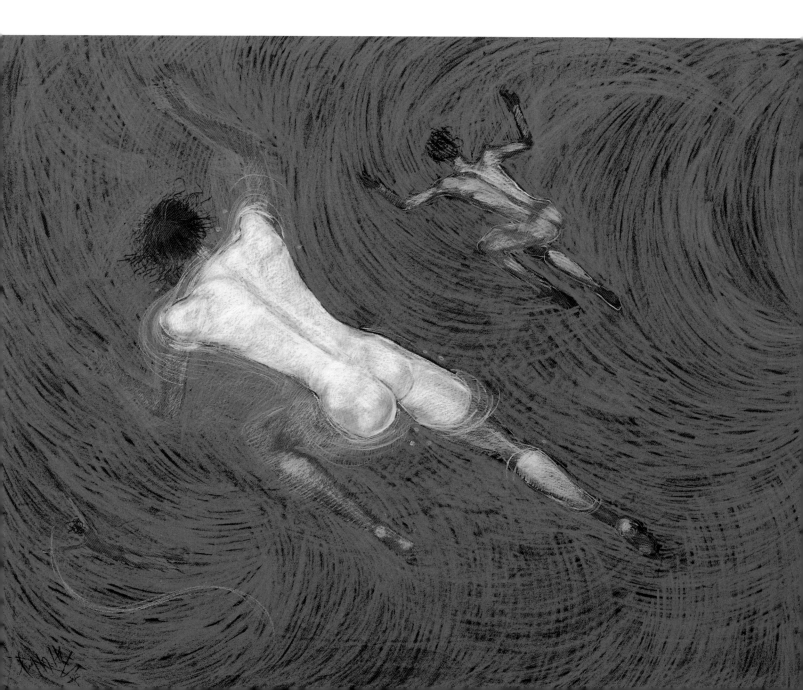

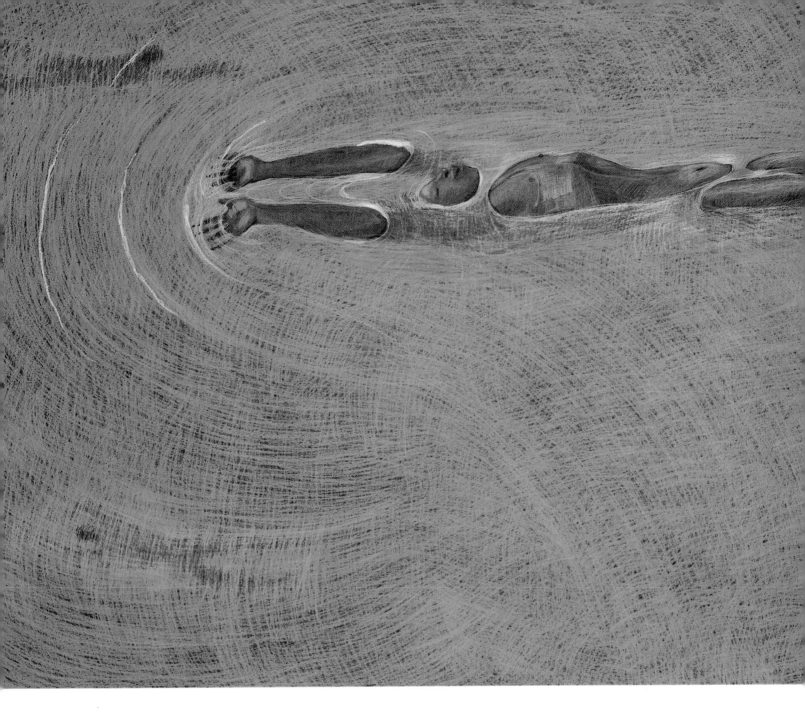

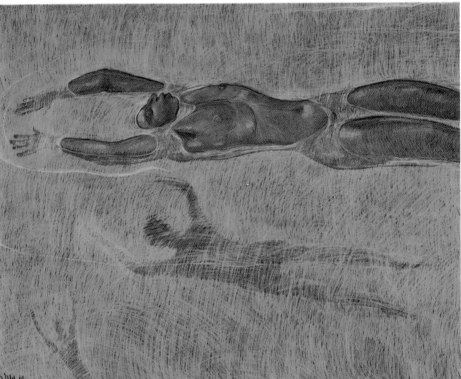

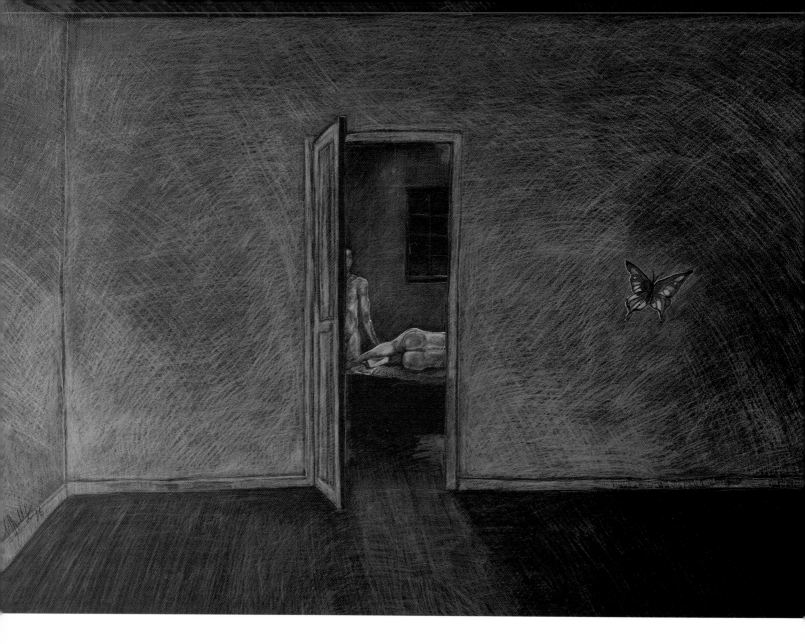

Interlude, 1985, color pencil, 36 x 48 inches.

Joseph and the Angel, 1983, color pencil, 36 x 48 inches.

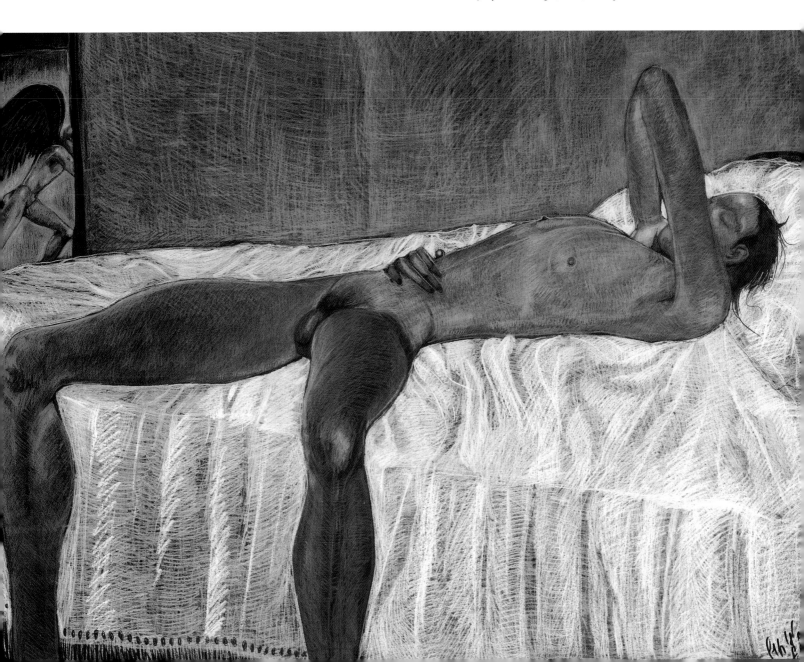

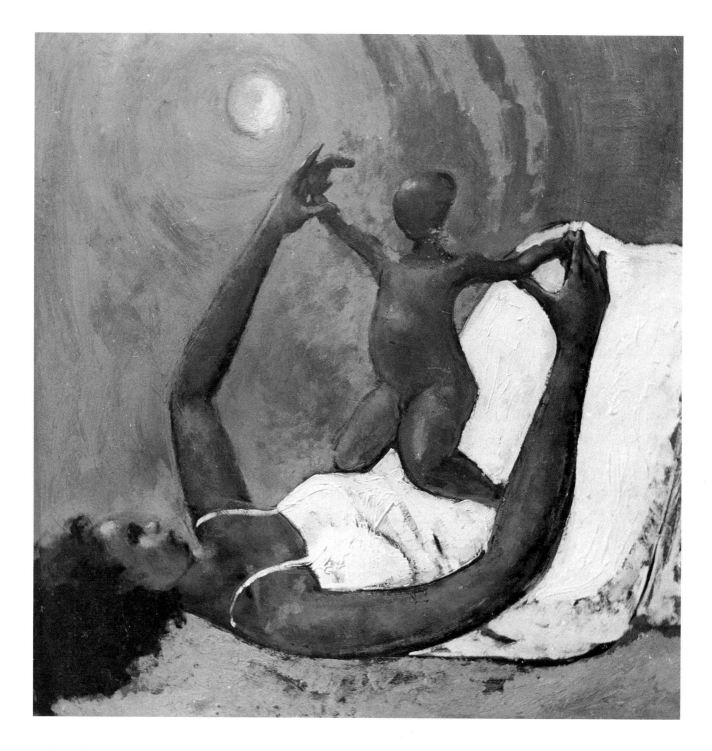

Mother and Child, 1957, oil.

(RIGHT) *Lovers I*, 1968, oil.

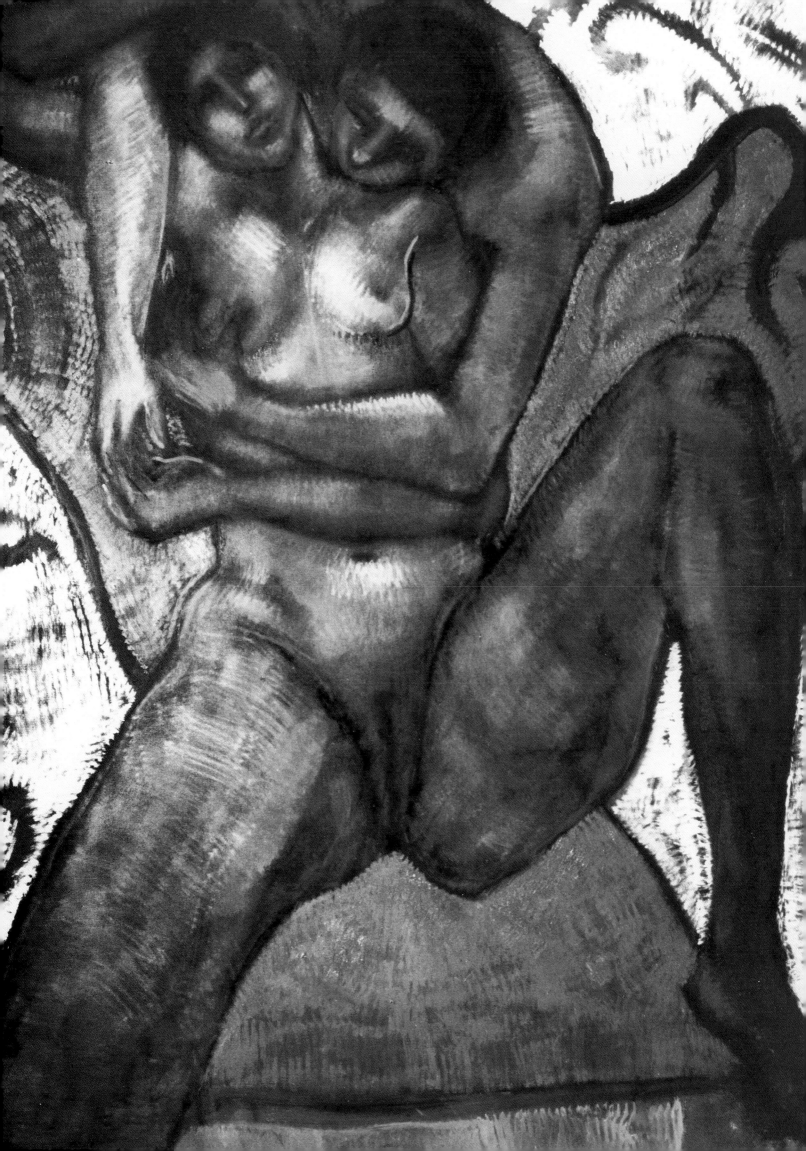

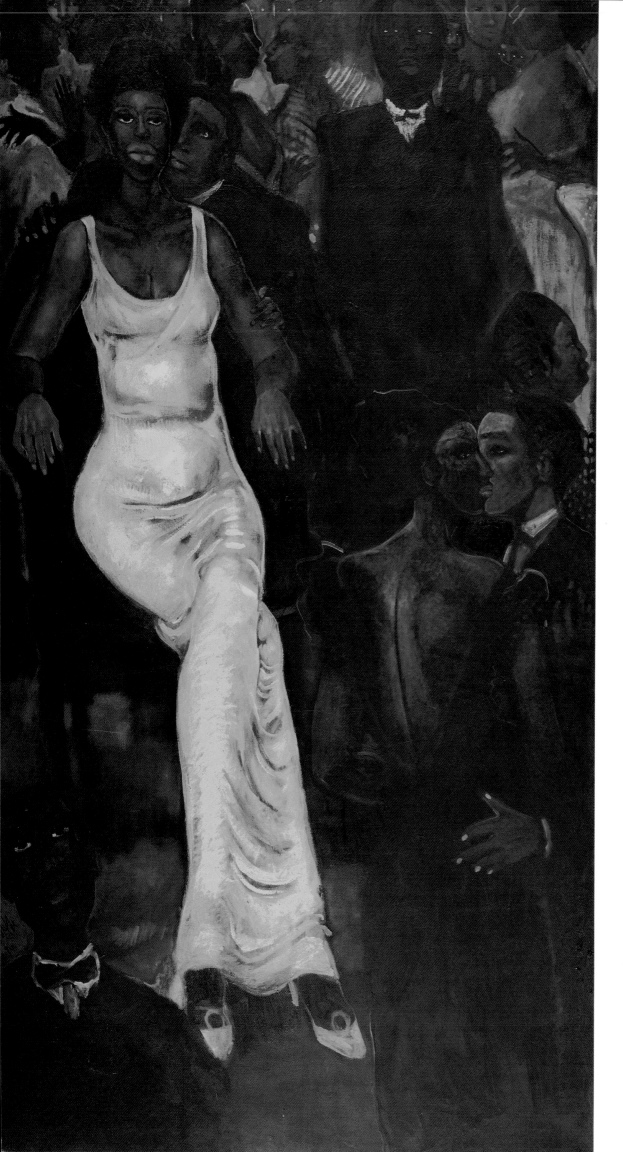

Saturday Night Social,
1993, oil, 70 x 39 inches

102

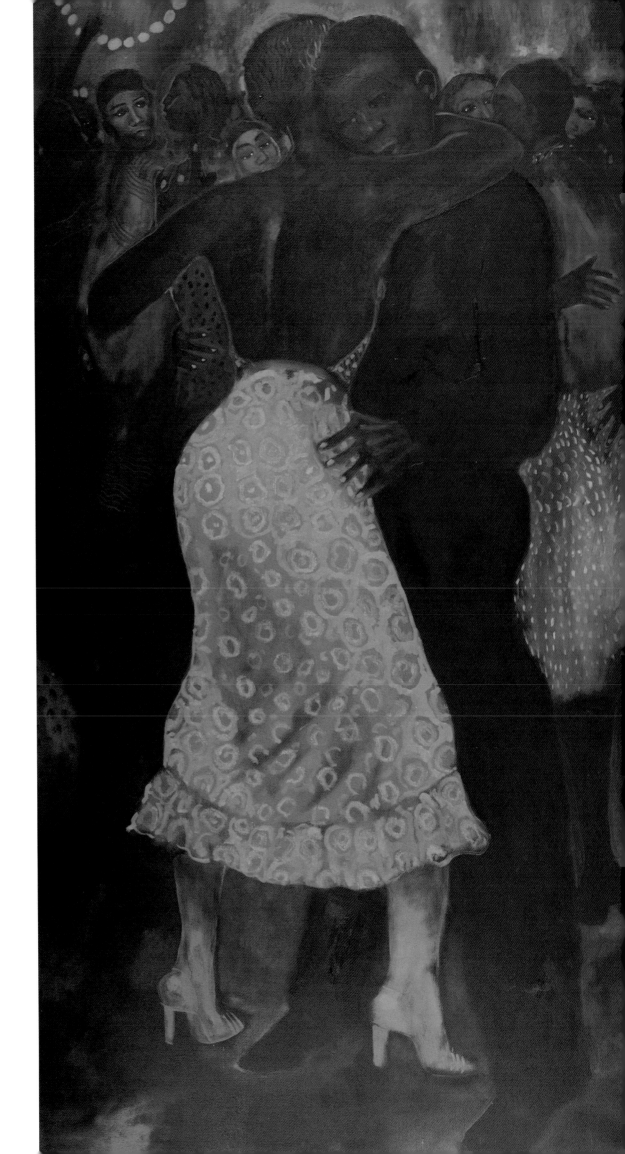

Lovers Dancing, 1993, oil,
70 x 39 inches.

103

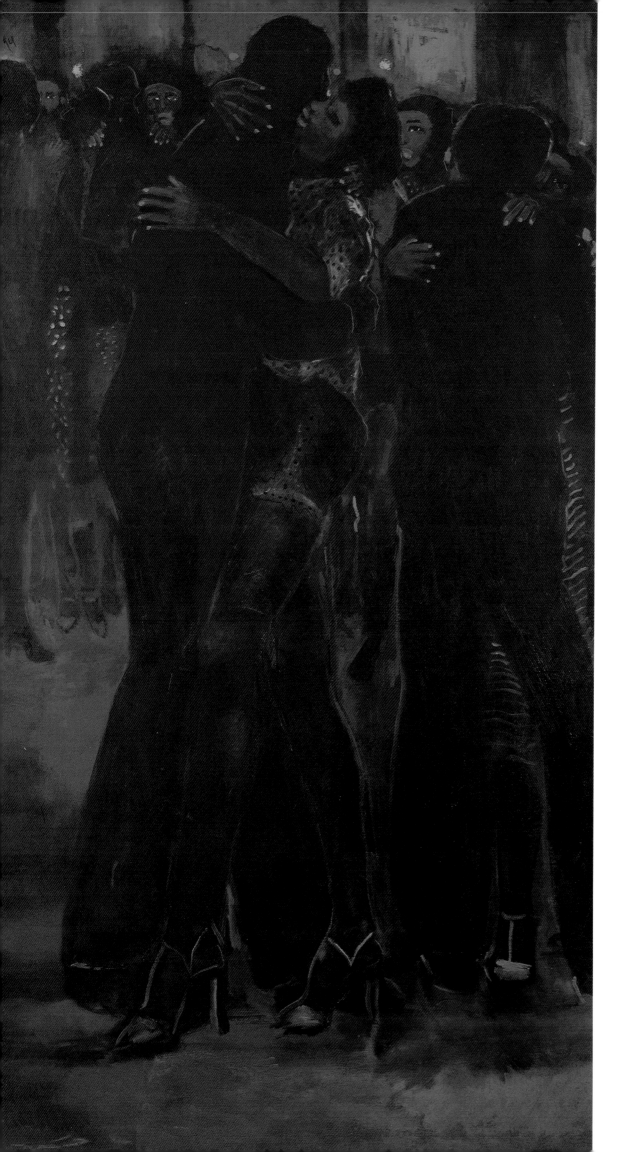

(LEFT)
Saturday Night Party II
1992, oil,
50 x 30 inches

(RIGHT)
Saturday Night Party I
1992, oil,
60 x 36 inches

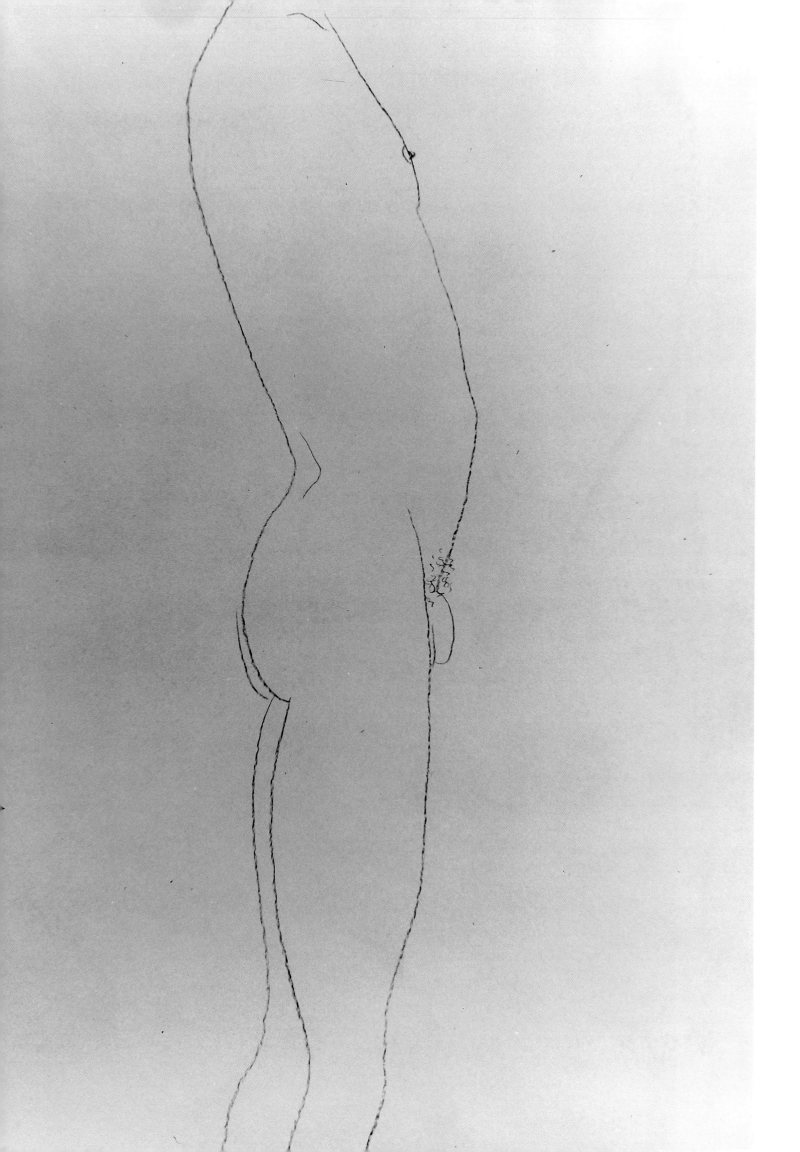

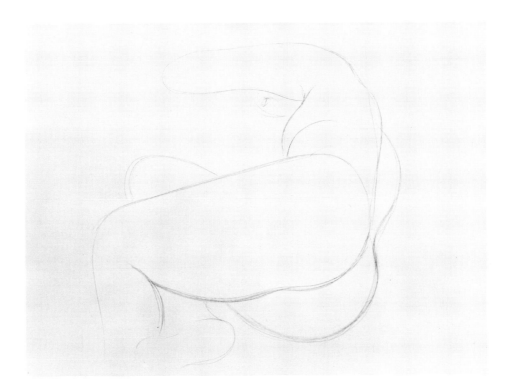

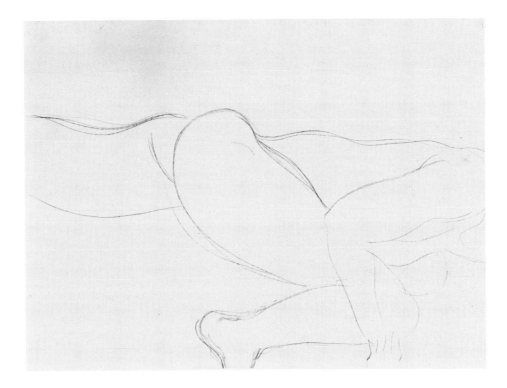

(left) *Nude Sketch #1*, 1975, pencil on paper.

(upper) *Nude Sketch #2*, 1974, pencil on paper.

(lower) *Nude Sketch #4*, 1968, ink on paper.

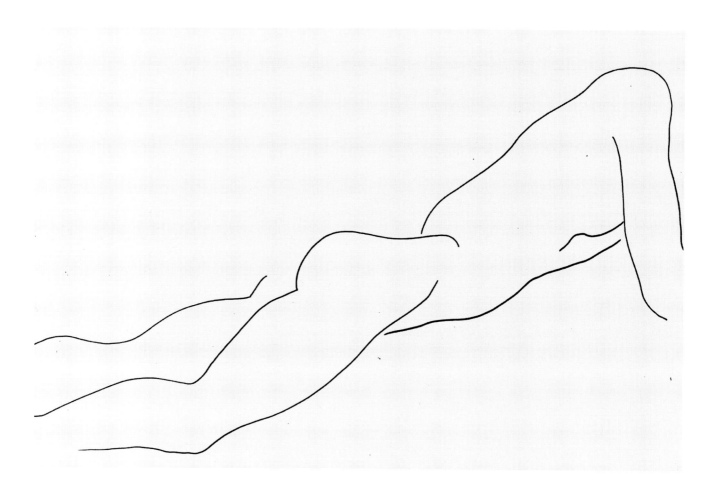

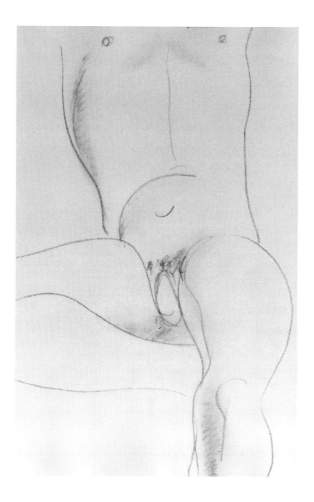

(UPPER) *Nude Sketch #6*, 1974, pencil on paper.

(LOWER) *Nude Sketch #7*, 1968, pencil on paper.

Photography Credits

Margot Astrachan

Peter Basch

Butler Photographers

Robert Cohen

Bob Cotrell

Hirosuke Doi

Kenn Duncan

Peter Fink

Dick Garrett

Ken Hack

Leo Holder

Gregory Kitchen

Bob Richardson

John Richardson

Moneta Sleet, Jr.

Betty Statler

Margot Weiss

G. Marshall Wilson

Exhibition Checklist

1. *Hot Flowers*, 1993, oil
 30 x 23 inches

2. *Lovers Dancing*, 1993, oil
 70 x 39 inches

3. *Saturday Night Social*, 1993, oil
 70 x 39 inches

4. *After Work I*, 1992, oil
 20 x 24 inches

5. *After Work II*, 1992, oil
 24 x 36 inches

6. *After Work III*, 1992, oil
 24 x 30 inches

7. *Bitching*, 1992, oil
 23 x 30 inches

8. *Black Veil*, 1992, oil
 10 x 8 inches

9. *Girl in Blonde Wig*, 1992, oil
 18 x 15 inches

10. *Girls Stepping Out*, 1992, oil
 59 x 36 inches

11. *Head of Girl*, 1992, oil
 10 x 8 inches

12. *Ladies' Club Members*, 1992, oil
 12 x 16 inches

13. *Ladies' Room*, 1992, oil
 12 x 16 inches

14. *New Shocking Pink Dress*, 1992, oil
 60 x 40 inches

15. *New York Beauty*, 1992, oil
 18 x 14 inches

16. *On Her Way Home*, 1992, oil
 60 x 40 inches

17. *Saturday Night Party I*, 1992, oil
 60 x 36 inches

18. *Saturday Night Party II*, 1992, oil
 50 x 30 inches

19. *Seated Nude*, 1992, oil
 24 x 20 inches

20. *Setting Sun*, 1992, oil
 20 x 24 inches

21. *Study of Three Women*, 1992, oil
 8 x 10 inches

22. *Veiled*, 1992, oil
 16 x 12 inches

23. *Victory*, 1992, color pencil,
 24 x 20 inches

24. *White Bodice*, 1992, oil
 16 x 12 inches

25. *Woman in a Black Lace Dress*, 1992, oil
 30 x 23 inches

26. *Woman in Blue Interior*, 1992, oil
 10 x 8 inches

27. *Black Woman in Black*, 1991, oil
 16 x 12 inches

28. *Dotted Glove*, 1991, oil
 16 x 12 inches

29. *Horsehair Hat*, 1991, oil
 16 x 12 inches

30. *Man in Black*, 1991, oil
 16 x 12 inches

31. *Twilight*, 1991, oil
 20 x 24 inches

32. *Crying*, 1990, oil
 10 x 8 inches

33. *Twilight in Katonah*, 1990, color pencil
 25 x 37 inches

34. *Callalillies*, 1989, oil
 23 x 30 inches. Collection: Barbara Johnson

35. *Seated Woman in White Flowered Dress*,
 1989, color pencil, 30 x 24 inches
 Collection: Regis Pagniez.

36. *Friends I*, 1985, color pencil
 24 x 30 inches

37. *Interlude*, 1985, color pencil
 36 x 48 inches

38. *Reclining Man*, 1985, color pencil
 23 x 29 inches

39. *Undressing Study*, 1985, color pencil
 29 x 23 inches

40. *Friends II*, 1983, oil
 20 x 24 inches

41. *Joseph and the Angel*, 1983, color pencil
 36 x 48 inches

42. *Resting*, 1983, color pencil
 32 x 41 inches

43. *Swimmers I*, 1983, color pencil
 36 x 48 inches

44. *Swimmers II*, 1983, color pencil
 36 x 46 inches

45. *Swimmers III*, 1983, color pencil
 35 x 46 inches

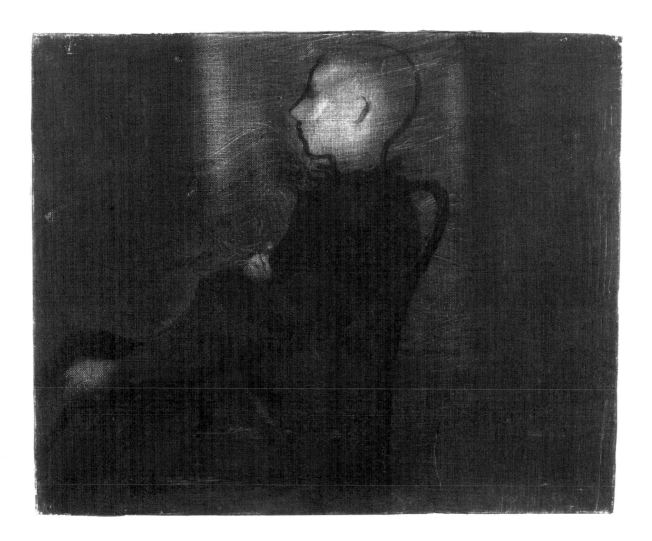

Portrait of a Concierge in Paris, 1966, oil.